G000076939

IMAGES
of America

LOGGING IN
PLUMAS COUNTY

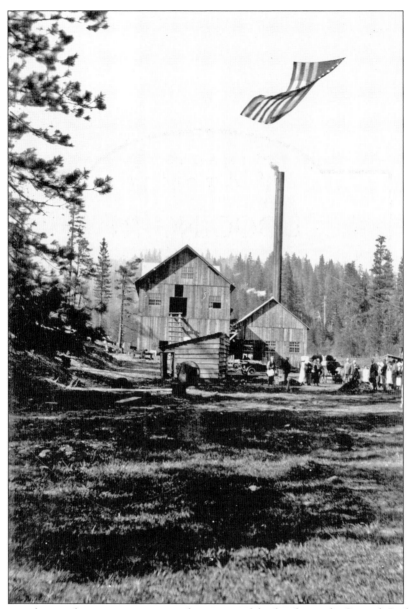

This photograph was taken to commemorate the cutting of the first log at the Spanish Peak Lumber Company's sawmill at Spanish Ranch on July 1, 1916. Local residents were invited to the event, and food and refreshments were provided for all. The mill operated until 1933 when the company went bankrupt, then resumed again under Meadow Valley Lumber Company until 1964.

ON THE COVER: Hughes's donkey engine crew takes a short break in 1911 to pose alongside their log chute with a small steam donkey yarder in the background. Although horses were rapidly replaced by steam power for skidding or yarding logs, they continued to play an important part in woods operations as cable and rope haulers or small log retrievers. For a time, horses continued to be used at landings for loading wagons. Standing fourth from left with an ax on his shoulder is Tennessee-born logger George McInturff. (Plumas County Museum Association.)

IMAGES

of America

LOGGING IN
PLUMAS COUNTY

Scott J. Lawson and Daniel R. Elliott

ARCADIA
PUBLISHING

Copyright © 2008 by Scott J. Lawson and Daniel R. Elliott
ISBN 978-0-7385-5929-2

Published by Arcadia Publishing
Charleston SC, Chicago IL, Portsmouth NH, San Francisco CA

Printed in the United States of America

Library of Congress Catalog Card Number: 2008921572

For all general information contact Arcadia Publishing at:
Telephone 843-853-2070
Fax 843-853-0044
E-mail sales@arcadiapublishing.com
For customer service and orders:
Toll-Free 1-888-313-2665

Visit us on the Internet at www.arcadiapublishing.com

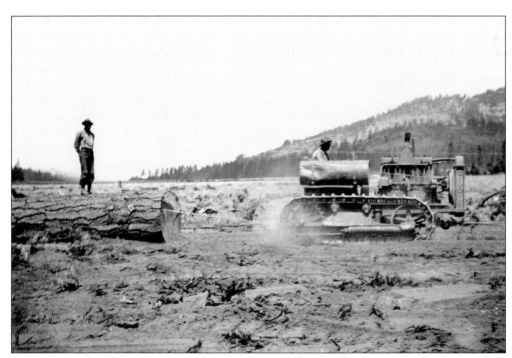

Reminiscent of a Three Stooges movie, this Clover Valley Lumber Company Cat Sixty pulls a pine log weighed down by a rider. It also appears the Cat may be hooked in tandem to a machine in front of it as cables appear to protrude from the front. This view was snapped on August 8, 1932. (Susan Haren collection.)

CONTENTS

ACKNOWLEDGMENTS

All photographs are courtesy of Plumas County Museum Association unless noted otherwise. Thanks to Paul Beckstrom; Nansi Bohne; Betty J. Boynton; James E. Boynton; David Braun; Orville Brown; Chester–Lake Almanor Museum; Debbie DeSelle; LaVerne Diltz; Jack Donnenwirth; Ray Donnenwirth; Nancy Elliott; Laure Gage; Jann Garvis; Ivy Grover; Ruth Haddick Estate; Susan Haren; David Hartwell; Gary Hinz; William Hopkins; The Huntington Library; Indian Valley Museum; Patricia Jester; Don Johns Sr.; Helen Kennedy; Loren Kingdon; Gene Lamont; Dean Lawson; the Lemm family; Bob Lowrey II; Thomas Maxwell; Richard McCutcheon; Lawrence Meeker; William Metcalf; Metcalf-Fritz Photographic Collection, courtesy of the Marian Koshland Bioscience and Natural Resources Library, University of California, Berkeley; Bob and Barbara Moon; Violet Cole Mori; Joe Musso; Mary Lynn Neer; Mike Nordt; Nevada State Historical Society; Earl Pauly; Myron Pauly; Plumas National Forest; Portola Area Historical Society; Mary Ann Pruitt; Harriet Richards; Robert Ridley; Jean and Robert Schoensee; Rip Scolari; Lori Simpson; Ellis Smith; Soper-Wheeler Lumber Company; the Spanish Peak Locomotive No. 2 Crew (Dave Amos, Jim Boyer, Sandy Coots, Ray Evans, Bill Henwood, Greg Jewers, Clay Johnson, Chris Coen, Bob Lowrey II, Len Mosley, Ken Myers, Ray Nichol, Jay Ricks, Ken Roller, and Sam Self); Martha Spooner Estate; L. E. Thomas; P. J. Thompson; Russell Turner; Vinton Bowen White; Williams House Museum; Larry Williams; and Rob Wood.

INTRODUCTION

Motivations for writing a book can be many. Our effort in *Logging in Plumas County* has a number of goals, the primary of which is to share an impressive collection of historic photographs relating to one of the most important industries to have existed in Plumas County.

As historians, we also share a passion for local history that encompasses all of its aspects. As a professional archaeologist, Dan has spent many years deciphering the remnants of past activities within the forests of the northern Sierra Nevada. Such evidence frequently includes the traces of old logging and railroad operations. He also does it for personal interest. Scott's interest in logging comes from his love of local history, from having worked in the woods himself, and from his logger ancestors going back at least to his great-grandfather. His father, several cousins, and an uncle have made their living from woods work as well.

In this book, we will present the history of logging as it occurred in Plumas County, which, in fact, mirrors almost exactly the growth of the same industry throughout the Sierra. Ironically, it was timber that sparked the largest peacetime migration in the history of the United States. The discovery of gold at one of California's first sawmills touched off the 1849 California Gold Rush, which proved to be the catalyst for the timber industry. Exploiting California's natural resources came easily to the forty-niners, and within a few short years lumber mills had popped up throughout the length and breadth of the Sierra.

Plumas County's first water-powered sawmill was located on Bachelder's Creek (now Bach Creek) on the Middle Fork Feather River in 1851. Close on its heels, a dozen or more mills spread throughout the county and began making boards and sawdust. Lumber for mining operations, cabins, tools, and myriad other uses and the miners' willingness to pay in gold prompted many would-be miners to become lumbermen. Many of these entrepreneurs first made their stake cutting lumber by hand using whipsaws in sawpits, which proved terribly hard work but was exceedingly profitable at the time.

As more people settled in the county and as industries and communities began to take on a semblance of permanency, lumber mills became even more in demand. For the first 50 or so years, the mills relied almost strictly on local demand. With the completion of the transcontinental Western Pacific Railroad in 1909, Plumas County began to play a part in the national demand for wood products. Many new mills tried to set up somewhere near the railroad to expedite their shipping process. Whereas in the past the mills were placed near the timber, now the logs were brought to the mill from increasingly distant locations. Production capacities of sawmills in the post–Western Pacific era were also greatly increased over earlier operations.

The story of logging in Plumas County also follows the technological evolution and the many advancements that occurred throughout the industry over the past 100 years. Even with the changes from handsaws and axes to high-speed chainsaws; from plodding oxen to huge diesel trucks; from smoke-belching donkey engines to Caterpillars and feller-bunchers, the work of logging still remains a tough, exacting, and dangerous occupation.

Sawmills have also undergone enormous changes. From waterpower, to steam, to electricity, mills have developed new and innovative ways to economically and efficiently cut lumber from the logs brought in from the woods. Circular saws found replacements with bandsaws, and now computers and lasers do much of the work formerly done by human skill.

We hope you will enjoy this look at the growth and change of logging and lumbering in Plumas County and the wonderful assortment of vintage photographs depicting this exciting and vital industry.

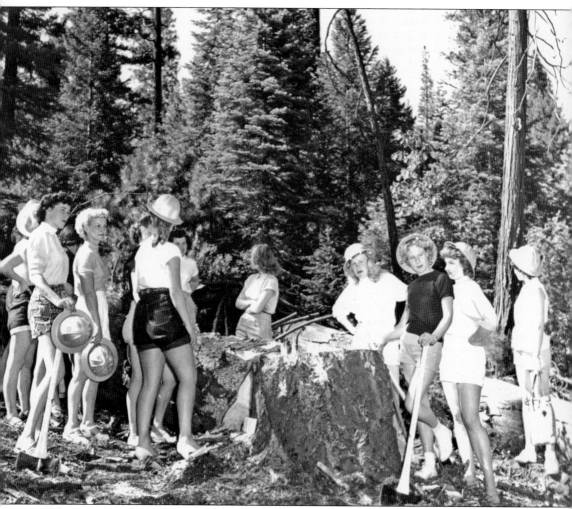

This group of unidentified young women stands triumphantly around the stump of a Douglas fir they have just felled with axes and a handsaw near Greenville. Labeled only as "College of Women Loggers," these ladies were instructed in the art of timber falling by a bare-chested burly logger who was a part of this mid-1950s Newsreel program.

One

LOCAL LUMBER DEMAND

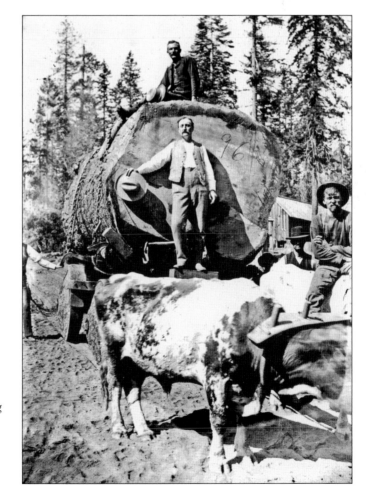

This group of unidentified loggers poses with a huge sugar pine log loaded on a solid-wheel wagon west of today's Bucks Lake in 1889. In the early years of logging, mules and oxen were used to skid logs from the woods to nearby mills. As the trees were cut and hauling distances increased, the need for reliable transportation demanded new technology. Wagons with solid wood wheels were developed to haul behemoths like the log pictured here. The loggers' imagination, innovation, and plain hard work became a tradition that is carried on to this day.

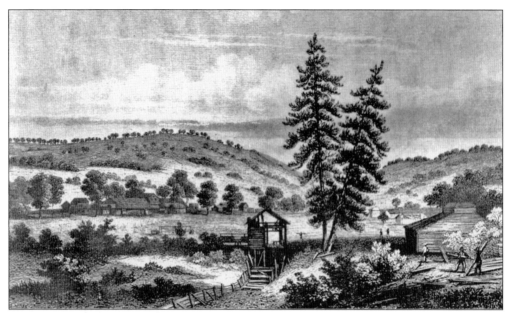

The discovery of gold in 1848 at Sutter's new sawmill at Coloma sparked an unprecedented rush of immigrants to California. With the miners came the need for lumber for mining enterprises, houses, stores, and many other uses. The northern Sierra Nevada was no exception: small, water-powered sawmills similar to Sutter's were erected literally overnight.

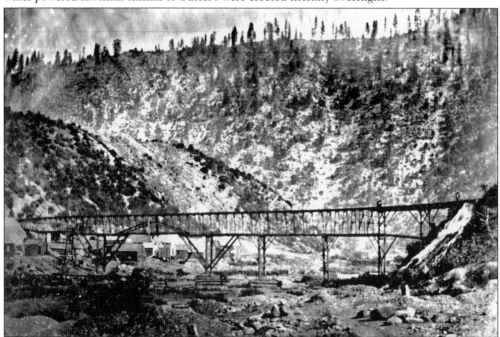

In what is now Plumas County, the situation was no different. As can be seen in this 1852 view near Rich Bar, lumber was used in the construction of a combination bridge and water flume across the river, a waterwheel, dam, a pumping operation, and many cabins. The lumber was probably cut at the sawmill located nearby the mouth of aptly named Mill Creek. (The Huntington Library, Western American Collection.)

Sawpits, or "bone and muscle" mills, were backbreaking operations but could be very profitable, with sawn boards commanding up to $1 per foot. Some miners were so anxious to get lumber that they even cut the trees and positioned the logs themselves. One would hope that the sawyers traded off the bottom-side duty regularly. (Metcalf-Fritz Collection.)

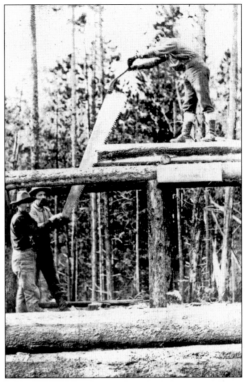

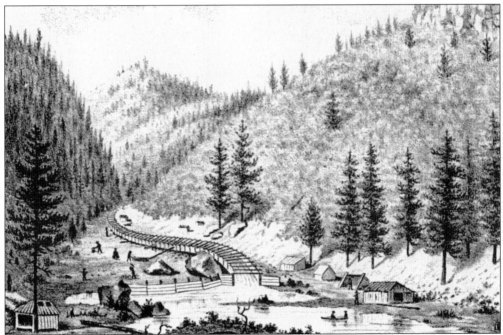

A fair number of sawmills sprang up in the Feather River region by 1851. Batchelder's Mill, on what is now called Bach Creek behind Claremont Peak, was one of the first on the Middle Fork Feather River to supply miners with lumber. The miners built diversion flumes large enough to carry the entire flow of the river.

Jobe Taylor was an early entrepreneur who built a gristmill and sawmill on the east edge of Taylorsville in Indian Valley. A millrace was hand dug from Indian Creek to provide power for the operation. This photograph was taken about 1890 and shows Taylor's Gristmill at left and the sawmill at right. The sawmill cut lumber for almost 50 years.

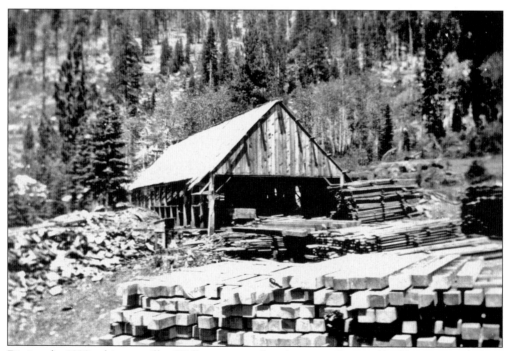

During the 1920s, this sawmill at Walkermine produced mine timbers and building materials from locally logged timber. Campbell's logging company provided the logs by log chute, horse-drawn wagon, and Mack trucks. (Harriet Richards collection.)

12

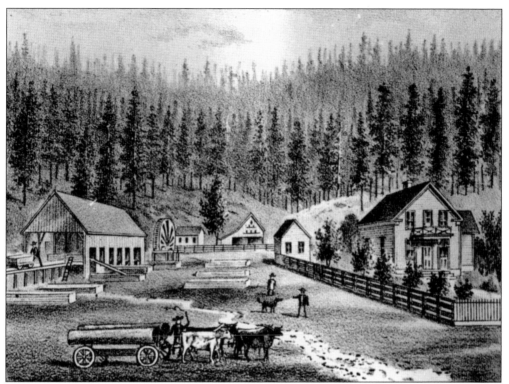

Early sawmills in Plumas County were for local markets and were always placed near the timber to be cut. Christian Gansner bought a sawmill west of Quincy in 1868, which he replaced with a more modern one in 1876. A new water-powered planing mill was attached to it because, as the *Plumas National* reported, "planing lumber by man power these days is too far behind the times."

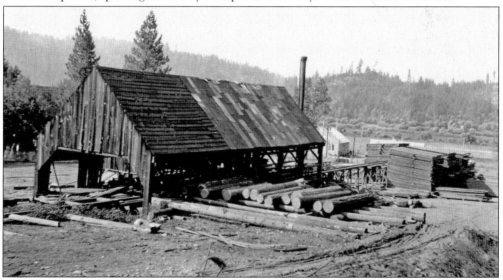

This photograph shows the same Gansner Sawmill in 1920. After sitting idle for many years, the old mill was converted to a steam-powered operation by Gansner's son-in-law, O. P. Payne of Payne and Davis Company. Today only a pile of decomposing sawdust remains to mark the site of one of American Valley's earliest sawmills. (Metcalf-Fritz Collection.)

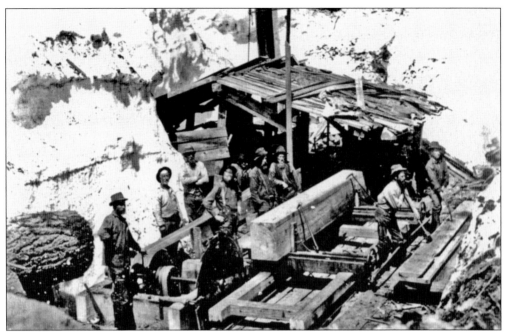

Water-powered mills began to be replaced by steam-powered operations when that machinery became available. Squires's steam-powered sawmill, complete with a whistle, at Gibsonville near La Porte, is shown in the snowbound winter of 1889. The large logs were wrestled into place on the mill by hand, while scrap lumber made up the mill's roof.

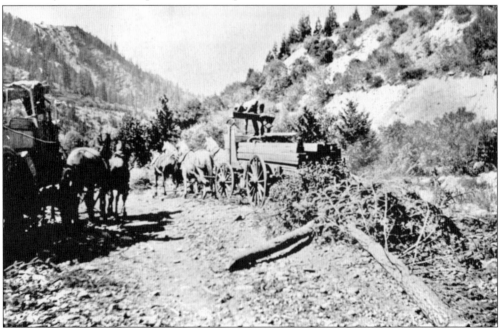

To transport their lumber to the miners and other local buyers, the Squires had several horse-drawn wagons. Because loads of green lumber were extremely heavy, small trees such as those lying in the road were cut and hitched to the rear of the wagon to act as a braking device and to help keep the wagon straight when descending steep grades. (Jann Garvis collection.)

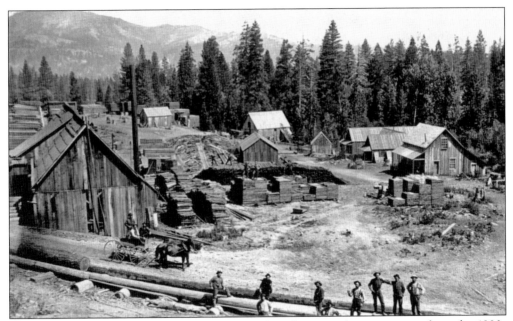

Knickrem's steam-powered sawmill near Mohawk Valley was a busy operation from the 1880s into the early 1900s. Note the stacks of cordwood to fuel the steam boiler. In the buggy is J. C. Knickrem, and in front of him are his loggers, who are standing at the over one-mile-long log chute that reached out into the stands of timber. In the background is Penman Peak at an elevation of 6,900 feet.

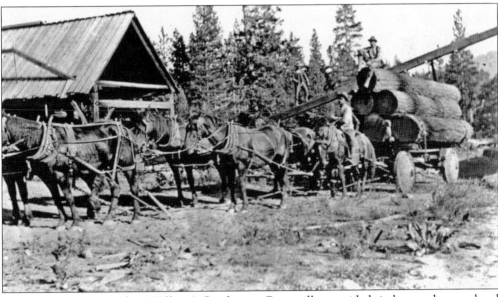

The Farrar Mill, located on William's Creek near Greenville, provided timber products to local residents. It later became the Nagler Mill. The man on the horse at right is Samuel V. Fisher of Indian Falls. Logging and sawmills provided necessary but dangerous occupations, particularly in the early days when gears and wheels were exposed and could easily snag a piece of clothing or a hand or foot.

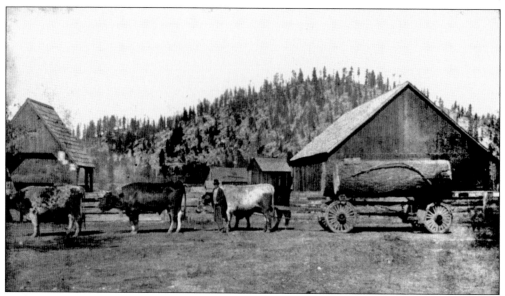

In this 1895 photograph, R. D. "Tune" Haun is seen driving Gansner's ox team loaded with two huge pine logs through downtown Quincy in American Valley. The Gansner mill sat about one mile west of town. The floor of American Valley was originally covered with groves of huge pine trees.

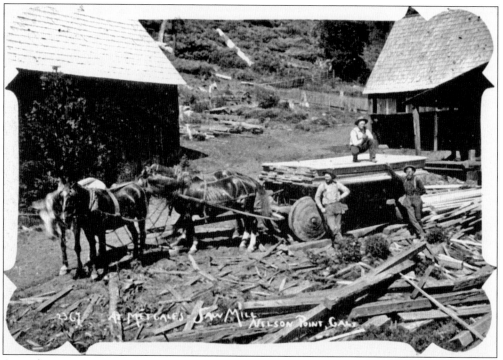

Samuel Metcalf operated several sawmills in central Plumas County: one near Cromberg, another at Spanish Ranch, and this one at Nelson Point. Besides providing lumber, the mills provided local men with work. Metcalf is shown here sitting on the wagon with his two-man crew loading planks for a local mining operation. (William Metcalf collection.)

16

Two

BEYOND LOCAL
LUMBER DEMAND

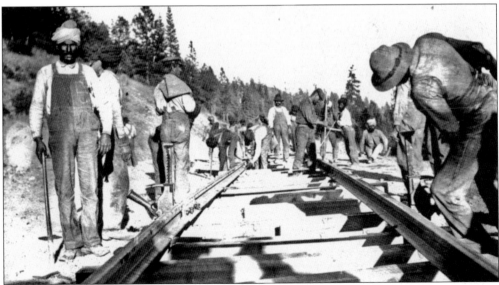

At the end of the 19th century, the coming of the Sierra Valley and Mohawk Railroad and then the Boca and Loyalton Railroad heralded a new era for lumbering in eastern Plumas County. Shortly thereafter, the construction of the Western Pacific Railroad further galvanized the local lumber industry with the means to access national and global markets. In this 1908 image, workers of various nationalities can be seen laying rail for the Western Pacific Railroad.

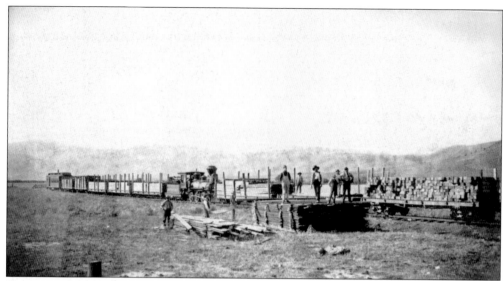

Constructed as a narrow gauge in 1885, the Sierra Valley and Mohawk Railroad was the first railroad to enter Plumas County. The line was constructed from Plumas Junction in Lassen County (near Hallelujah Junction) to a point just east of Beckwourth by 1885; however, due to failing finances, work ceased at this location. It is shown here about 1895 when work on the railroad was resumed. (Nevada State Historical Society Collection.)

The Sierra Valley and Mohawk Railroad languished until 1895 when Henry Bowen purchased the line and completed it to Clairville, near today's Mabie. Renamed the Sierra Valleys Railroad, it ran sporadically until it was finally absorbed by the Western Pacific Railroad and discontinued in 1918. It was responsible for a large timber rush to the Clairville area where the stands of old-growth pine were decimated. This photograph shows the Clairville Hotel before the fire of 1898. (Nevada State Historical Society Collection.)

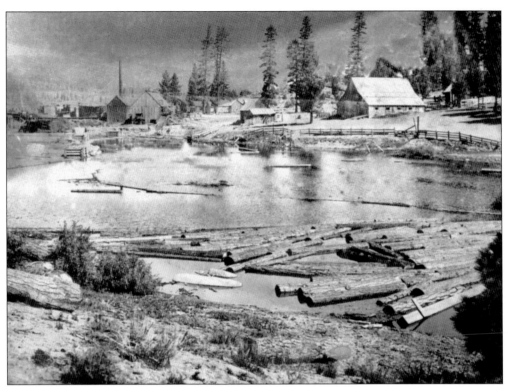

The Clairville Lumber Company Mill was located on the Middle Fork Feather River, about two miles east of Clairville. The millpond was created by seasonally damming the river. Ironically, after 1905, this and other mills along the Sierra Valleys Railroad made some of their greatest profit manufacturing railroad ties for the new Western Pacific Railroad.

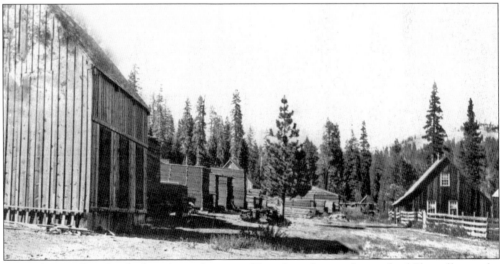

Located on Willow Creek about five miles west of Portola and two miles north of Clairville was the Totten Mill, which predated the Sierra Valleys Railroad but took advantage of the opportunities when the railroad came into the area. In 1905, Totten Mill became Feather River Lumber Company's Mill No. 1. The new company had a railroad spur constructed into the mill. This view is of the Totten Mill yard and houses about 1895. (Nevada State Historical Society Collection.)

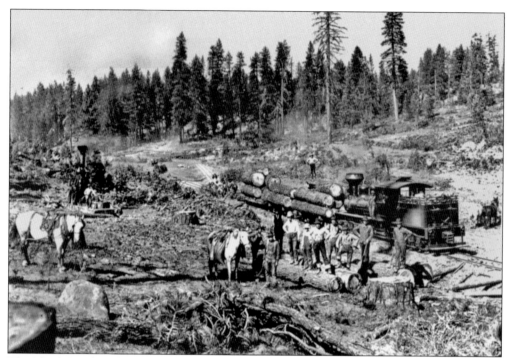

The Marsh Lumber Company is shown at its timber operation located in Mapes Canyon south of Clover Valley in this 1905 view. From left is the rigging horse with sawbuck packsaddle, the landing donkey for yarding logs, another pack horse with large water bags, the crew, a Shay engine with logs loaded on flat cars, and two horses used to cross-haul load logs onto the flat cars.

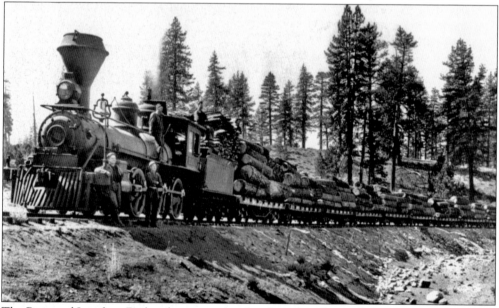

The Boca and Loyalton Railroad was completed as far as Loyalton in July 1901. It was extended across Sierra Valley to Beckwith by November of the same year. The standard-gauge railroad not only hauled finished lumber to the Central Pacific Railroad near Truckee but also transported logs to the mills in Loyalton. Here their engine No. 6 makes a stop for a photograph in 1905.

Three

THE FALLERS AND BUCKERS

For 100 years, there was very little change in the tools used by the tree fallers of the Sierra Nevada. The means to bring the logs from the stump to the landing and on to the sawmill, however, changed considerably over time. From horse and oxen, to steam power, to internal combustion vehicles, the logging industry mechanized rapidly after the 1880s. In a day during which animal power was still the norm, these two Sierra Lumber Company fallers and their canine mascot strike a pose during the 1870s with their axes, wedges, and other tools arrayed around them. They are holding a long whipsaw, often referred to as a "misery whip," and are starting a back-cut into a large sugar pine. The saw was pulled back and forth in long, sweeping motions to make the cut. Recycled whiskey bottles with wire hooks at the top often served as portable oil containers to keep the saw lubricated.

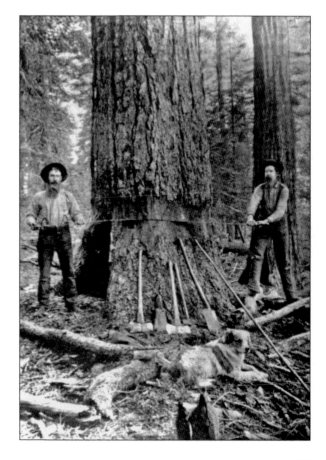

Forested tracts of land were surveyed or "cruised" to estimate their economic potential. At the same time, the costs of logging and milling were factored in to ensure the ultimate profitability of the operation. Tracts might belong to a lumber company or the timber rights purchased from private landowners. After the organization of the national forests in Plumas County in 1905, timber sales on public land became increasingly common. (Plumas National Forest Collection.)

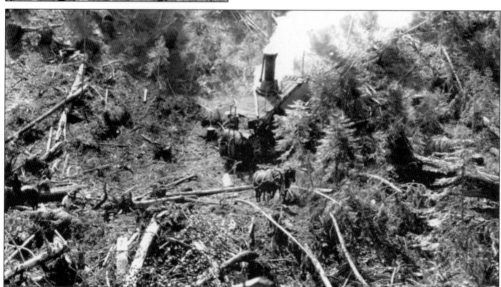

A logical order to logging operations maximized efficiency. The terrain usually dictated timber harvesting methods. With the development of steam donkeys, destruction of old-growth forests became almost unavoidable. Early in the 20th century, the practice on national forests was generally to remove the larger, over-mature, and dying timber, leaving the smaller trees. In time, that philosophy changed and various sized trees, including smaller ones, were harvested. (Rob Wood collection.)

On a hot summer day in 1919, onlookers watch two of Feather River Lumber Company's fallers work on taking down a large Ponderosa pine near Delleker, just west of Portola. A wire rope or cable, known as a "choker," has been laid on the ground across the projected path of fall to make it easier for the woods crew to secure it to the donkey engine's yarding cable.

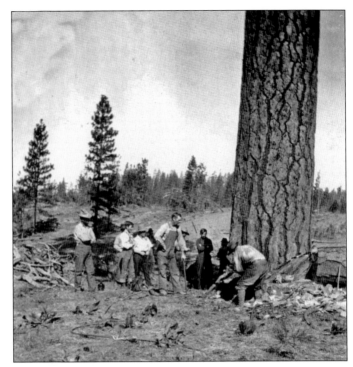

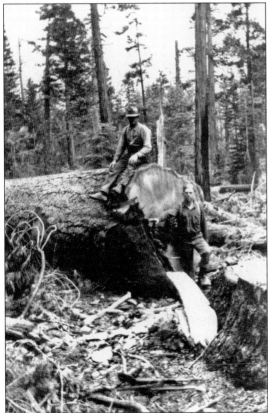

A good faller could drop these forest giants exactly where he desired. A freshly cut 8-foot-diameter sugar pine was felled during logging operations for the California Fruit Exchange near the head of Mohawk Creek under Mills Peak in 1923. Seated on the log is Blackie Brooks who worked as head rigger, and standing on the "stump shot" is Bob Bibby, who was hook tender. (Rob Wood collection.)

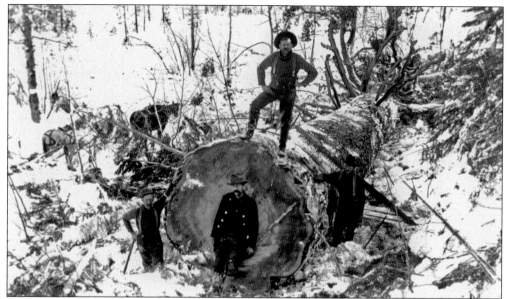

Once the tree hit the ground, the work of preparing the logs for transport began. The first step involved removing the limbs from the tree so it could be cut, or "bucked," into manageable lengths. While logging generally happened from spring through autumn, operations sometimes occurred during inclement weather, as is apparent in this snowy scene near Sattley in 1895. (Russell Turner collection.)

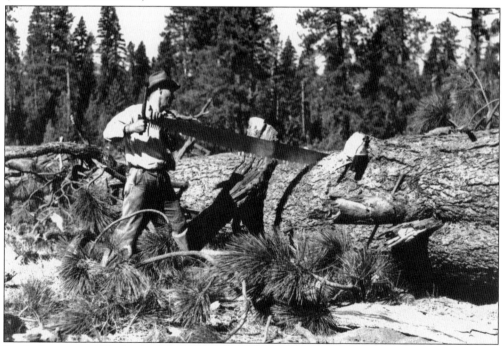

Limbed trees would be bucked to preferred lengths of 16 feet-6 inches or 33 feet to produce the maximum amount of lumber. The Clover Valley Lumber Company bucker shown here is cutting through a recently dropped Jeffrey pine. His oil bottle hangs from the side of the log as he works his way through this gnarly giant. Damaged or deformed segments of trees were often left behind.

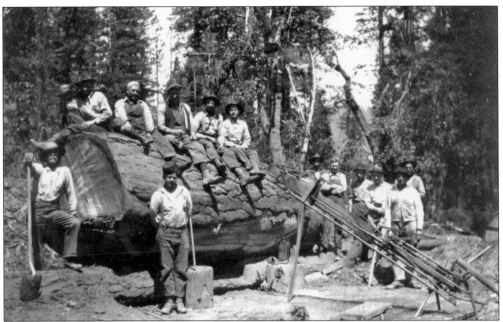

Some of the initial advances in cutting techniques occurred for bucking logs. Drag saws powered by air, steam, and gasoline were developed and widely utilized in the early 1900s, particularly on log landings where the saws could be more easily moved around. Some were larger in size and relatively stationary, such as this California White Pine Lumber Company saw in 1910. Logger George McInturff is the fourth man from left on the log.

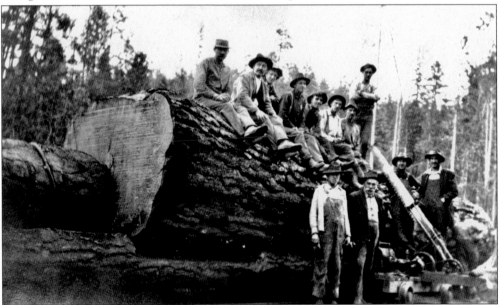

Most drag saws were relatively small and mobile. Some were moved on a small rail system as seen here, while others had small wheels. The basic models lacked wheels and were dragged by either horses or men (hence the name "drag saw") to wherever they were needed. Basically, the reciprocating saw blade was set on the log and dragged back and forth to cut. Ralph Gill is fifth from left on the log.

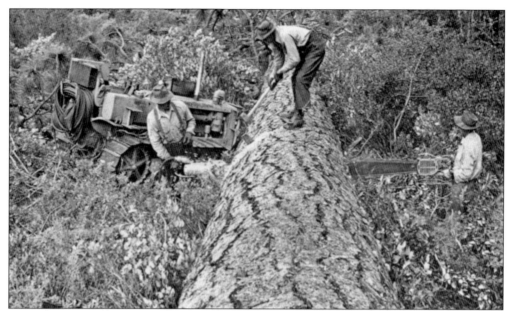

By the 1940s, electric chainsaws, powered from tractors, were available. These saws could be used for falling or bucking timber but were very cumbersome and required at least two men to operate. The man on the left is operating the saw while the man on top of the log drives a wedge into the cut to keep the log from pinching the saw. The man on the right is holding the "stinger."

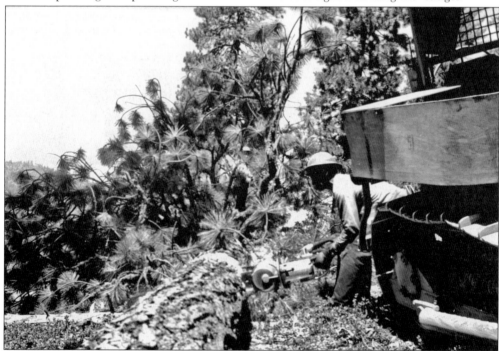

This view of a bucker with a one-man electric saw powered from the nearby tractor shows him cutting through a modestly sized Jeffrey pine. This photograph is taken later in time as evidenced by the use of hardhats. The bucker's partner can barely be seen through the limbs running a tape to measure off the next log.

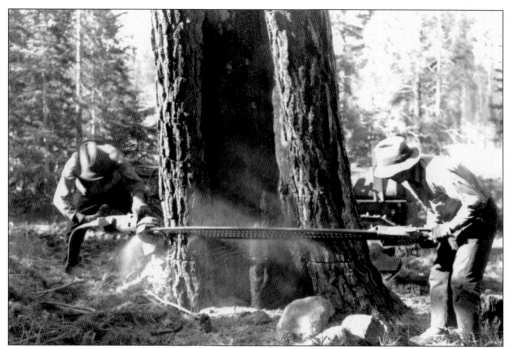

Ed White of Loyalton is operating an electric chainsaw for the Clover Valley Lumber Company while his helper holds the "stinger" in this 1945 shot. Use of these large saws required relatively level ground, as they were powered off the electric system on the Caterpillar tractors. The Upper Last Chance Timber Sale was comprised of approximately 50 percent white fir and 50 percent Jeffery pine. (Susan Haren collection.)

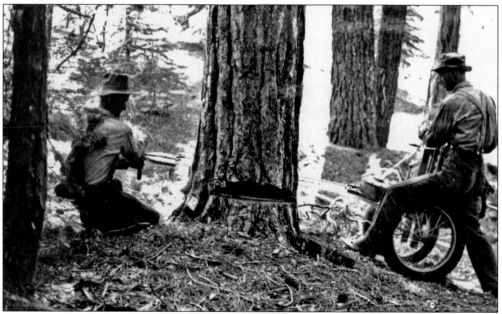

Saws began to evolve rapidly by the 1930s. The first ones were massive and not particularly efficient or reliable. This photograph shows a wheeled, gasoline-powered chainsaw in use near Calpine in 1935.

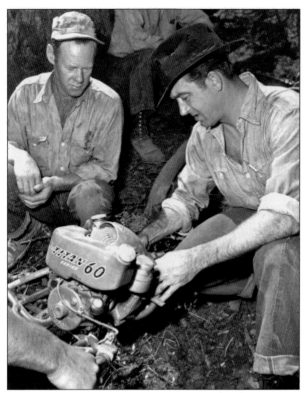

In the years following World War II, gasoline saws were finally becoming small enough that one man could operate them. An excellent example of what is now a rather archaic one-man chainsaw is shown here being manhandled by Hollywood actor John Payne in the early 1950s. These publicity photographs were taken in Plumas County when he was filming a movie called *The Blazing Forest*, released in 1952. Another film featuring logging that was shot in Plumas County was *Guns of the Timberlands*, starring Alan Ladd and Frankie Avalon. Payne was perhaps best known for his role in *Miracle on 34th Street*.

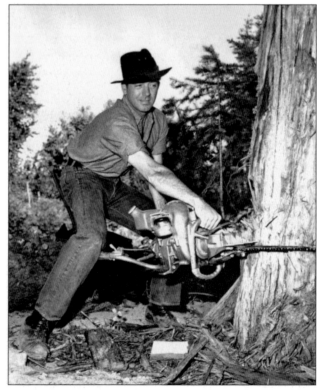

Using a misery whip and axes, Al Brandt (left) and an unidentified faller for Maxwell Brothers Logging assume a casual manner as a nicely sized ponderosa begins its final descent. This photograph and many others demonstrate that there was little in the way of protective clothing or equipment, aside from perhaps gloves, in use during the early years of logging. (Thomas Maxwell collection.)

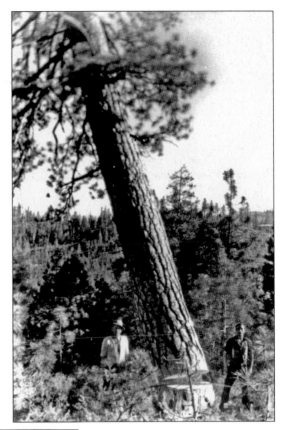

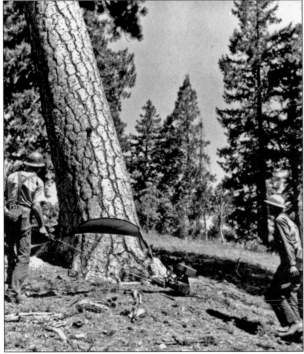

These 1950s fallers are using a two-man gasoline chainsaw to drop a large ponderosa pine. Note the "hard boiled" hat on the man at left, more typical of an underground miner's hat than a woods worker's. Hard hats had come into common usage by the early to mid-1950s due to insurance regulations.

29

Even with the development of lighter, more reliable one-man chainsaws, the basic methodology for falling a tree has not changed. Timber faller Mike Nordt of Quincy demonstrates the basic process of falling a tree, which includes (top) making the initial undercut and (bottom) making the back cut. Once the tree is on the ground, the work of limbing and bucking into log lengths begins.

Four

THE WOODS CREWS

Logging is hard, sweaty, gritty work. The men who perform these day-to-day tasks are known as the "woods crew." This includes the choker setters, knotbumpers, equipment operators, and others who make sure the logs get from the woods to where they can be loaded and hauled to a sawmill. In this image, a "trail" of logs is being "yarded" on a chute to the loading area. At the front is a "pig" or wood boat carved from a handy log and used by the greaser to swab the chute as the trail moved along. Attached to the pig is his grease bucket, ready for the trip in. In 1915, the Spanish Peak Lumber Company used 113 barrels of oil and grease for their chutes. Most donkey yarding operations employed an engineer, fireman, woodcutter, chute greaser, head chaser, and assistant chaser. The two chasers rode the logs to the landing or the mill, and then they and their tools were hauled back in the pig.

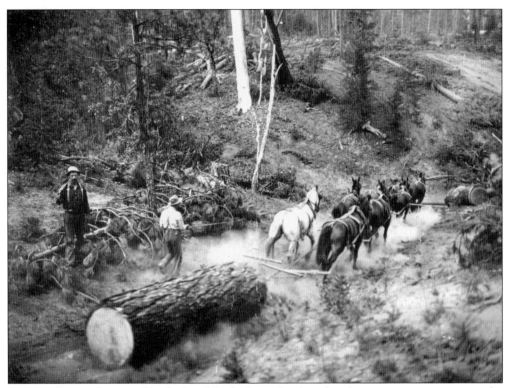

Once a tree was down and limbed and bucked into log lengths, the next step was to move the logs to a landing. In the early days, or in low-budget operations, logs were simply dragged, or "skidded," on the ground using horses or oxen. Here a log is being skidded down a draw in 1912 near Butterfly Valley. Bill Bell is the man on the right, driving the team.

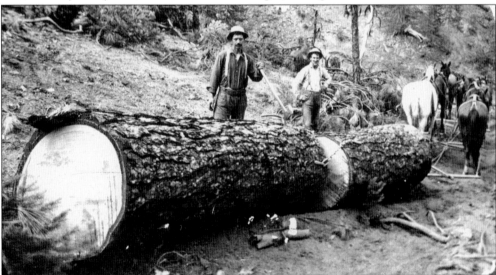

In this same operation, Bill Bell has halted the team to take on a second log that is linked to the first using a short stout chain with spikes on each end, called a "log dog." Horse teams were inexpensive to operate but were limited to relatively even terrain. These high-value sugar pine logs were headed to the Moore-Skagg's Sawmill in Butterfly Valley, near Keddie.

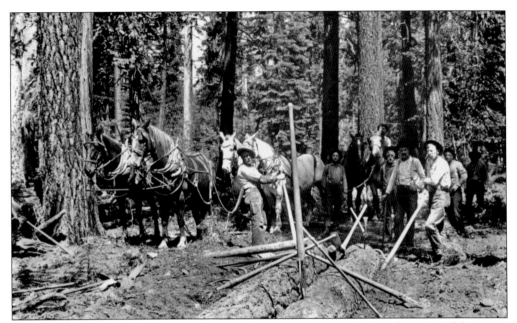

One widely used method of log transport in Plumas County was the log chute. Small logs were laid parallel, continuing end on end for great distances. Here a chute is being constructed near Spring Garden in 1911. The construction crew poses with their "cant hooks" and "peaveys," used for jockeying the logs into final position after the horse team had them roughly placed. (Pat Jester collection.)

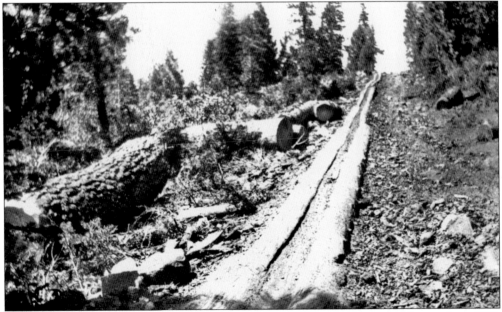

Campbell's Logging Company's mile-and-a-half-long chute at Walkermine is shown about 1921. This steep uphill view shows the horse trail to the right. Scattered along the side are logs that have "jumped" the chute. These were generally left until the final cleanup. When viewed from Walkermine, it was said the logs could be seen billowing smoke from each side as they shot down the chute. (Harriet Richards collection.)

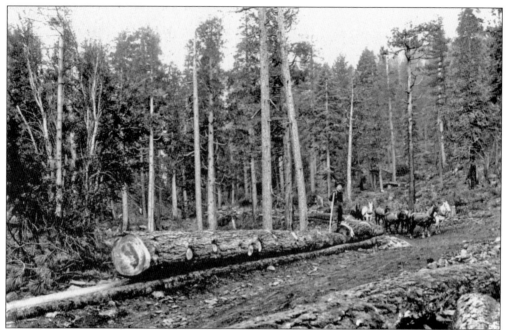

Chutes were a definite improvement over simply dragging logs in the dirt. Costing anywhere from 29¢ to $1.03 per foot to build, this was still the most cost-effective way to move logs. In this *c.* 1900 view in eastern Plumas County, a team of seven horses and mules are pulling in a lengthy trail of logs.

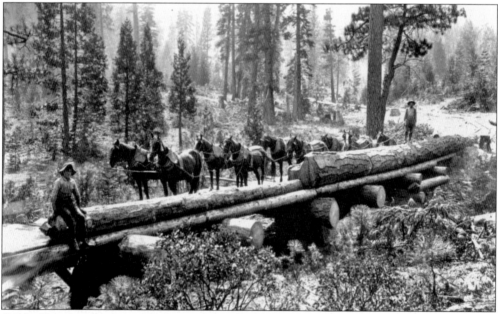

Cribbed log chute bridges were a common method for crossing drainages or other uneven terrain. These structures were constructed of short lengths of logs notched and crisscrossed to support the chute. For horses, a parallel pathway and plank bridge over the drainage was necessary, adding to the expense of construction. This chute and bridge were in use by the Sunset Mill Lumber Company near Sattley in the 1890s. (Russell Turner collection.)

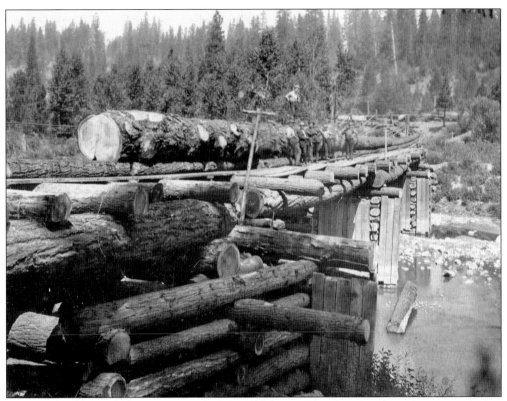

Log chutes were sometimes quite massive as this California White Pine Lumber Company operation near Cromberg shows. Although usually built to last at least several years, they were still subject to the whims of Mother Nature and could be wiped away in a single storm event. This chute connected with a Western Pacific Railroad siding. A primitive telephone or "jerk" line for communicating with the donkey engineer can be seen strung along the chute. (Ruth Haddick collection.)

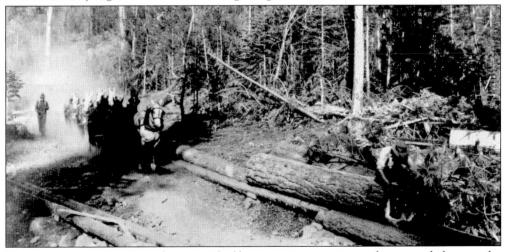

This horse team is bringing along a trail of logs at an intersection with a second chute in the foreground. Sitting on the lead log is the grease monkey, or swabber, who was responsible for brushing on the grease in front of the trail. Though it was not a particularly dangerous job, the swabber still had to exercise caution so as not to get run over by the logs. (Violet Cole Mori collection.)

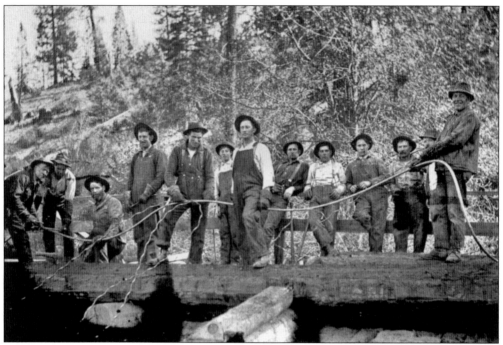

One constant chore for the woods crew was maintaining the health of the wire rope or cable used in yarding in the logs. In this 1913 view, a California White Pine Lumber Company crew is splicing a section of one-inch main line cable in a log chute near Cromberg. (Pat Jester collection.)

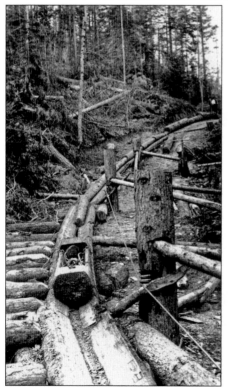

Quincy Lumber Company's pig sits loose in the chute while a trail of 11 logs is brought in. The trail chasers rode the logs into the landing or the mill from the woods and used the pig for the ride back. Note the spool posts used on curves to keep the main line close to the chute so that it did not pull the logs out.

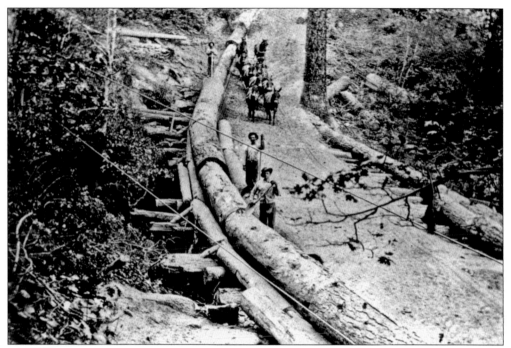

This 1890s view west of today's Bucks Lake shows a mule team working logs down an elevated log chute. With the rise of steam power replacing animal teams in the early 1900s, the road alongside the chute was no longer needed. Notice the cribbed log bracing allowing both the logs and teams to maintain an even gradient, particularly important when using animal power.

While the chutes were left behind when logging was completed, their remains can still occasionally be encountered in the woods. Chute logging was undertaken above Massack in the late 1910s. In 1987, U.S. Forest Service archaeologists were able to retrace a considerable amount of the old chute system based on observable remains. In other areas, the old chutes have vanished completely. (Plumas National Forest Collection.)

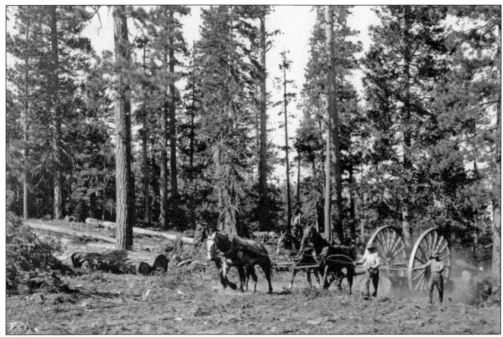

One interesting means of skidding logs was the development of what were appropriately referred to as "big wheels." Logs could be partially suspended, and a team of two or four horses could be harnessed to pull the load. This photograph shows a two-man horse crew with big wheels at work for the Marsh Lumber Company in 1911. Marsh operated north of Beckwourth from about 1908 to about 1915. (Plumas National Forest Collection.)

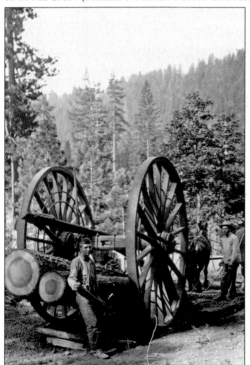

This is a view of the back end of a set of big wheels attributed to the Clover Valley Lumber Company. This long-lived company succeeded the Marsh Lumber Company and was operating in the Crocker Mountain–Clover Valley area between 1921 and about 1925. After 1925, Clover Valley Lumber Company continued logging operations in the Clover, Squaw Queen, and Last Chance Valleys, ceasing in 1956. Big wheels were only useful in gentle terrain. They were very common in logging operations in the western United States between 1905 and 1925. (Harriet Richards collection.)

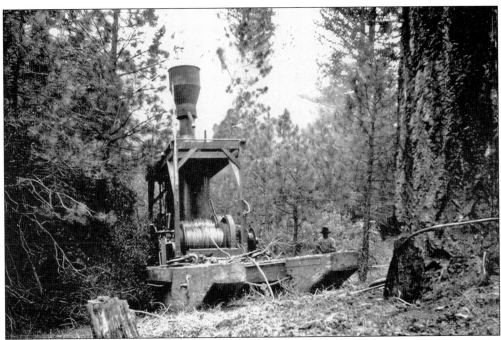

Steam-powered winching machinery called "donkeys" revolutionized the timber industry. The Dolbeer was introduced in 1882, and several competitors such as Washington and Willamette soon followed. A donkey was placed on a landing and played out lengths of cable to yard logs back to it. This Spanish Peak Lumber Company donkey is moving to a new setting in the woods north of Spanish Ranch in July 1923. (Metcalf-Fritz Collection.)

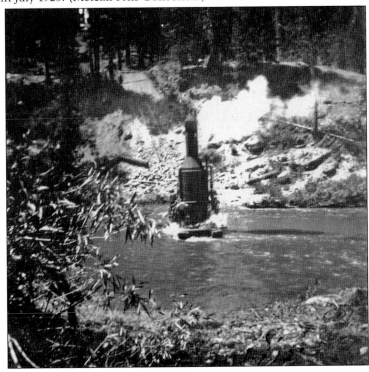

The steam donkey became an icon of the logging world. Not only did they become the primary means of moving logs, they also found many other uses. Donkeys could suspend logs and load wagons or railroad flat cars using a series of pulleys and cables. George Malloy is operating this steam donkey as it pulls itself across the Middle Fork Feather River near Cromberg on July 8, 1912. (Ruth Haddick collection.)

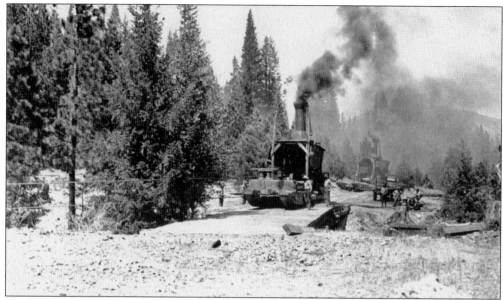

A large roader donkey owned by the California Fruit Exchange is moving itself to a new site on Smith Creek near Graeagle in 1924. The huge timbers serving as a framework and skids would eventually wear out, but the engine could be detached and placed on new skids whenever needed. (Rob Wood collection.)

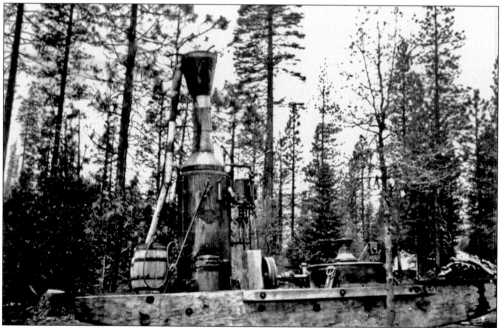

In 1923, this Dolbeer donkey was termed a "relic" that was used to do odd jobs for the Spanish Peak Lumber Company. Note the hand-hewn timbers for the skids. These engines were responsible for a great many forest fires. On this donkey, the pipe running from the top of the smokestack down into the wood barrels works as a makeshift spark arrester device. (Metcalf-Fritz Collection.)

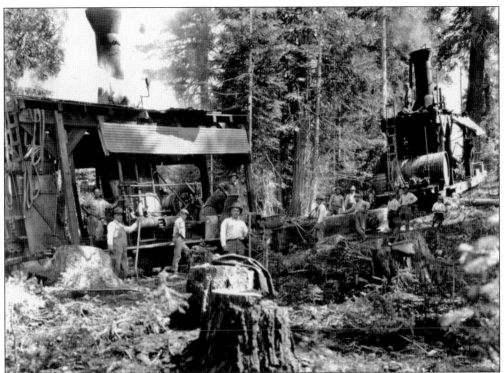

Two donkeys are shown moving in tandem near Graeagle in 1923. A Seattle yarder is in the lead with a Tacoma swing donkey in the rear. While these rigs appear to still be wood burners, over time many donkey engines, particularly roaders closer in to the mill, were converted to oil burners to reduce fires started from sparks. (Rob Wood collection.)

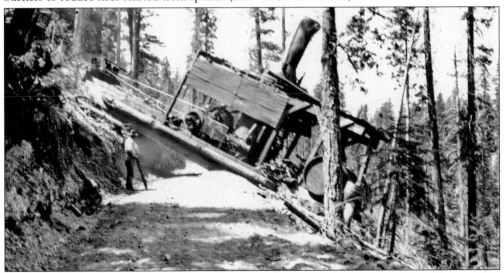

Steam donkeys could operate on very steep slopes, and sometimes it seemed the donkey crews would try to push them to the limit. This 1924 view is of the California Fruit Exchange's Seattle yarder pulling itself up a considerable grade near the head of Smith Creek, crossing a freshly constructed road in the process. Crew member Cleave Summers stands nearby watching the donkey's progress. (Rob Wood collection.)

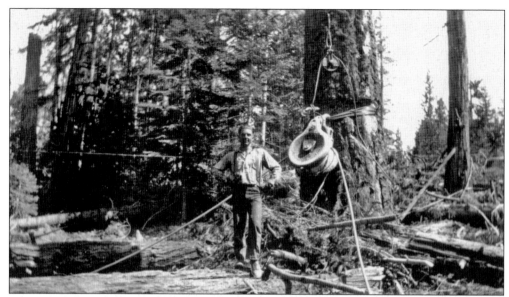

Miles of cable, earlier referred to as wire rope, was used in donkey yarding. Huge block and tackle systems were necessary, particularly with the advent of high-lead logging. This 1920 Graeagle area shot shows Bob Bibby, whose position was titled as a "frogger," standing next to a bull block rigged to a tree where logs from the woods were loaded onto the chute for the trip to the mill. The pulley weighed 950 pounds. (Rob Wood collection.)

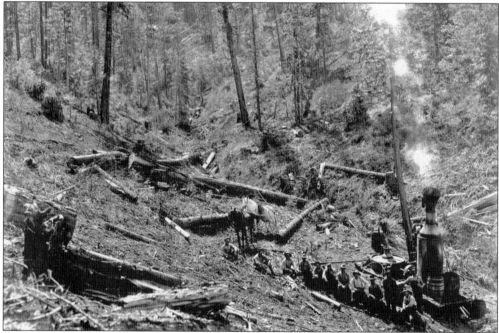

While donkeys were efficient and allowed logging in difficult terrain, the downside was the many fires they caused and the destructive ground skidding patterns that left little regeneration. As time went by, U.S. Forest Service officials began to discourage their use. A California White Pine Lumber Company donkey crew poses next to an old-style yarder in this 1912 photograph. George McInturff is fourth from the left.

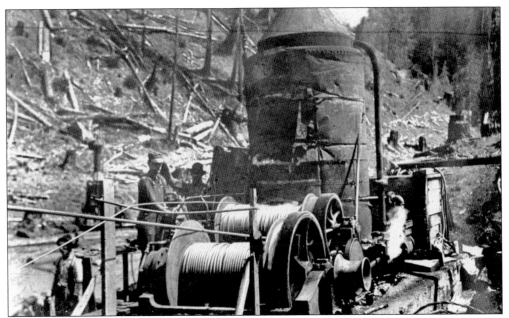

This bruised and battered double-drum, Washington-style donkey engine had seen many seasons in the woods when this photograph was taken. The severely degraded condition of the area immediately surrounding the engine was typical for ground-based skidding operations. Often very little regeneration was left behind.

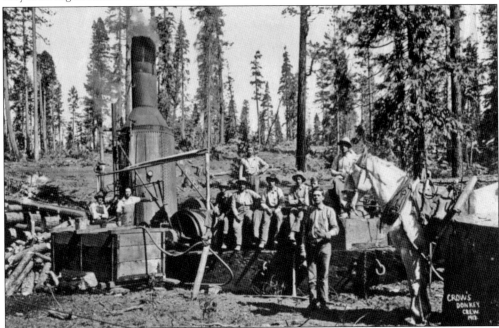

The California White Pine Lumber Company, based out of Loyalton, had been logging at Cromberg since 1910. By 1911, the company had acquired enormous timber holdings in the Spring Garden area. They brought logs to railroad sidings on the Western Pacific where they were loaded onto flat cars and shipped to the Loyalton mill. This 1913 photograph is of their logging subcontractor Crow's crew in the Spring Garden area. (Pat Jester collection.)

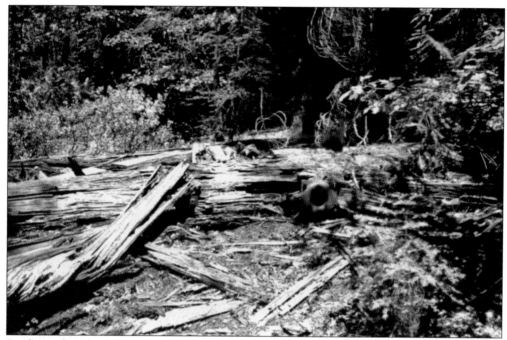

By the mid-1920s, concern over fires and environmental damage, and the development of the Caterpillar-type tractor led to the demise of the steam donkey. By the end of the decade, there were very few in operation. Evidence in the woods of their use is occasionally encountered in the form of decaying skids such as this one from a Spanish Peak Lumber Company operation near Snake Lake.

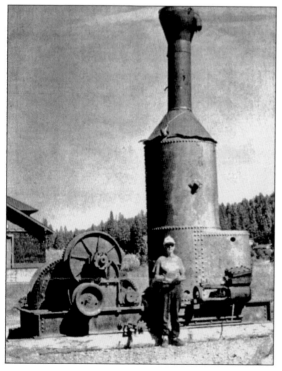

Although most donkeys had been scrapped out for their metal by the end of World War II, occasionally an intact specimen can still be found. This large donkey was purchased in 1995 by John Redd of Greenville and, with community assistance, was placed on display in the park near town.

High-lead logging utilizes a system of block and tackle and thousands of feet of cable. One end of a log is suspended from the ground during yarding to the landing. This reduces the drag common to ground lead logging. A strong and tall conifer at the landing was selected, then climbed and trimmed. Here Bob Bibby trims a "spar tree" near Graeagle in the early 1920s. (Rob Wood collection.)

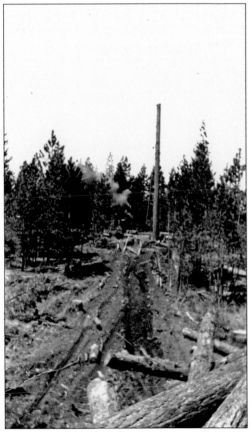

The first overhead or high-lead yarding operation reportedly occurred in California in 1913 and reached out some 1,800 feet. That operation employed an overhead carriage between spar trees, lifting the logs clear of the ground. This spar tree above Mohawk Valley in 1923 is being used to yard logs along the ground from the pile in the foreground to where they are loaded onto trucks. (Rob Wood collection.)

45

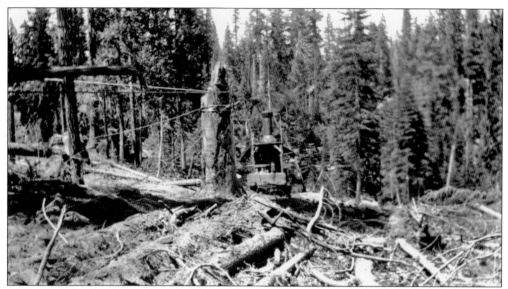

The strain on the spar trees was enormous and occasionally they would break, which could result in severe damage and bodily injury. In 1924, a spar tree snapped "on a hard pull," creating a real mess on this California Fruit Exchange landing near Mohawk Valley. Yet, as the caption on the back of this photograph reads, "no one [was] killed." (Rob Wood collection.)

The resulting work of a spar tree and donkey engine is illustrated in this 1923 photograph titled "Me again, I piled up this bunch of logs, 772,000 board feet." It would take a mighty brave hook tender to scramble around on that pile unhooking chokers from logs. (Rob Wood collection.)

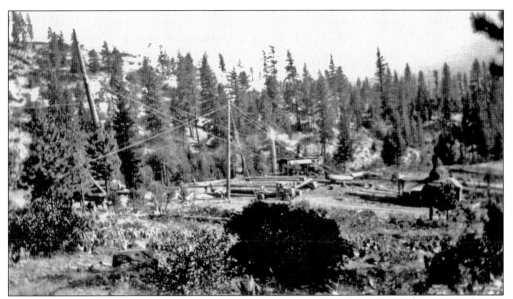

This view shows the California Fruit Exchange operations on the side of Penman Peak near Graeagle in 1921. At left is the yarder pole connected to the bull donkey at center. Also at center is a Mack truck being loaded by a spar pole, and a swing donkey can be seen on the far right. (Rob Wood collection.)

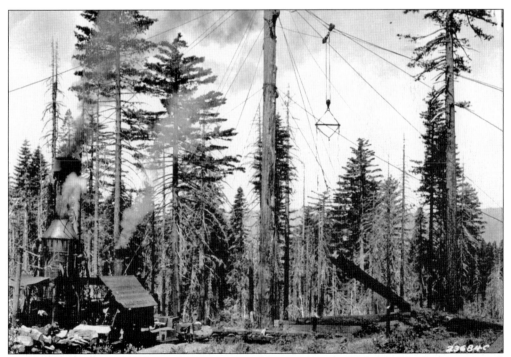

This 1920s Massac area operation spar tree is rigged from a "snag" or dead tree. The donkey-powered, high-lead system is yarding a cedar log into the landing where two donkeys are operating, one for yarding and one for loading. The spar tree has also been pressed into service for loading, placing logs on railroad flat cars that can be seen at the bottom of the photograph.

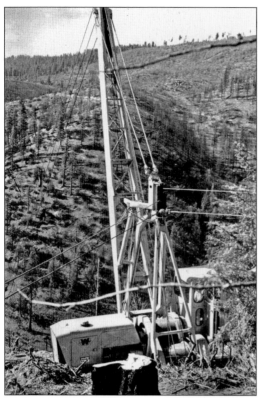

Over time, spar trees were replaced with portable steel yarder units. This photograph shows the Clover Logging Company's Washington yarder in operation during the late 1970s or early 1980s. Due to the perceived higher economic return for the amount of manpower expended, this type of logging was brought back in vogue by the U.S. Forest Service in the 1980s in Plumas County after a 50-year hiatus.

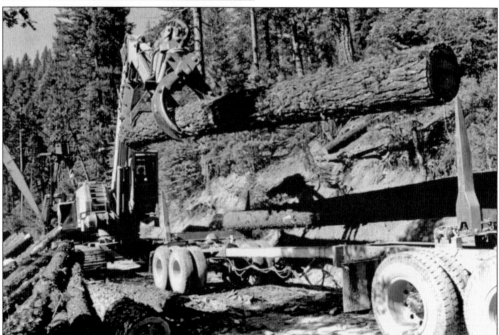

This Barko 550 track loader is working alongside the Clover Logging Company's Washington yarder. Like their A-frame predecessors, these shovel loaders could operate in very tight landings, sometimes only as wide as the logging road itself.

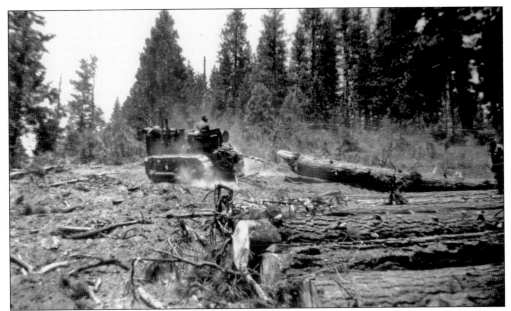

Following World War I, gasoline-powered tractors were developed for logging use. By the end of the 1920s, track-laying tractors such as this Indian Valley area one had almost completely replaced donkey engines as yarding equipment. Tractors were powerful and very maneuverable. They could avoid residual stands of trees, and the elimination of a boiler meant far fewer fires. The U.S. Forest Service encouraged the transition from steam power to internal combustion. (Gary Hinz collection.)

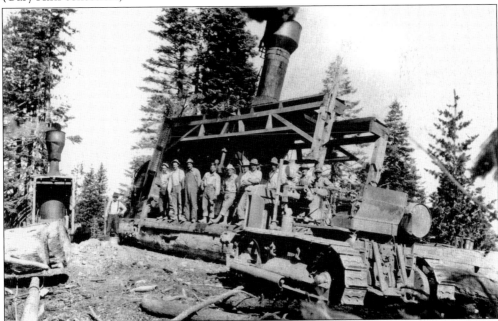

This Spanish Peak Lumber Company tractor sits in front of two of their steam donkeys at Camp No. 4 north of Spanish Ranch in August 1928. Identified from left to right are Charley Glice, Charley Johnstone, woods boss Cal Cole, Dude Hayne, Ernest Sanford, Mac ?, Mr. MacDonald, unidentified, Gorham Bloxham, Frank Hayne, and Frank O'Neil. (Lemm family collection.)

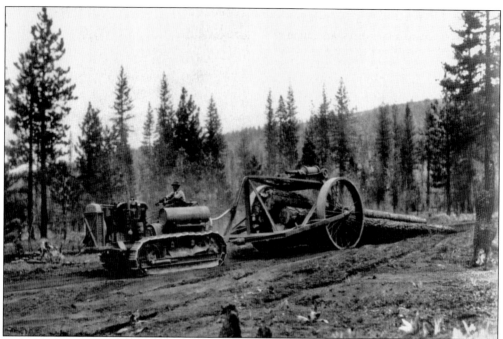

As with most advances in the industry, adaptation of existing technology played an important role. Here a Best-60 gas-powered tractor is pulling a set of Robinson hydraulic metal big wheels used by the Feather River Lumber Company in the mid-1920s. These had evolved from horse-drawn big wheels used earlier and proved very successful. Note the lack of a protective canopy for the operator and the exposed motor on the tractor.

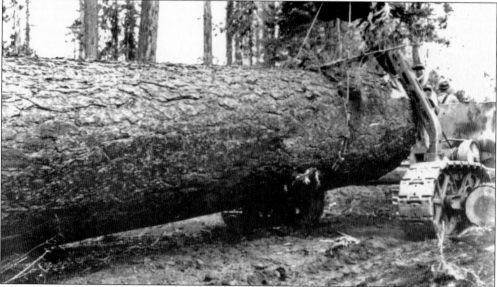

The next step after the hydraulic big wheels was the development of the arch. This late-1920s photograph of the Maxwell Brothers Logging Company shows an early arch with Athey tracks pulled by a tractor to skid a large sugar pine to the landing. Caterpillars were more versatile than donkeys and could make stump-to-landing trips in good time as well as work steep ground. (Thomas Maxwell collection.)

This Allis Chalmers tractor was working near Greenville in 1935 with Carl Lemm as the operator. Note the fantail at rear center for attaching the chokers. The "nubbin" on the end of the choker cable was placed into one of the slots to secure it to the tractor, while the other end was wrapped around the log. (Lemm family collecton.)

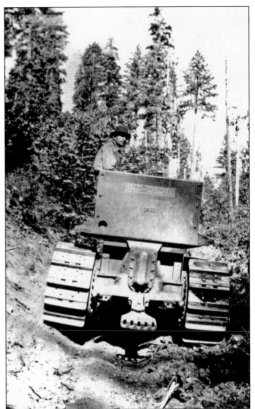

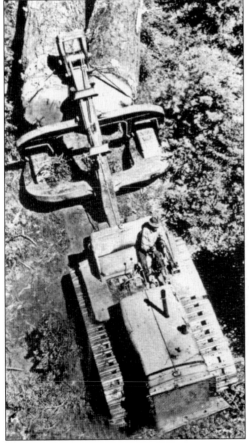

Red River Lumber Company of Westwood had one of the largest fleets of tractors in California and was constantly experimenting with developing new and innovative methods for bringing logs out of the woods. In this image, taken from a lofty tree, the tractor can be seen pulling a set of heavily laden arches toward the landing.

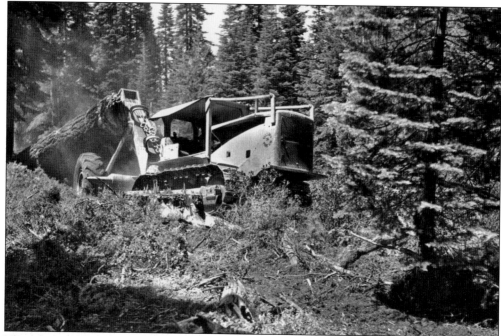

This photograph shows a Collins Pine diesel-powered tractor with a rubber tire arch bringing in an impressive turn in the late 1950s. A turn refers to a single trip from the stump to the landing. Ultimately arches were prohibited on federal lands, and later on private land as well, because of the extremely wide skid trails they produced. By the 1950s, diesel had largely replaced gas-powered tractors.

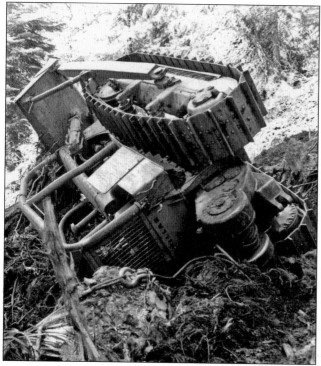

Logging is numbered among the most dangerous industrial occupations in the United States. Occasionally accidents occur, such as this tipped over D7 Caterpillar belonging to Glenbrook Logging Company. This event happened on Slate Creek, west of Quincy, on June 21, 1967. For the most part, though, operators tend to keep their equipment well grounded.

A Sikorsky 64 Sky Crane is shown flying in a turn to an Erickson Logging Company landing above the North Fork Feather River in the late 1970s. In the landing, a 966 Cat is shown loading Nichols Company's truck. Helicopters such as these could lift up to 28,000 pounds under ideal conditions and make a turn from the landing to the woods and back in several minutes or less.

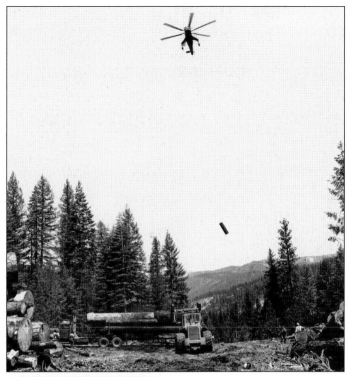

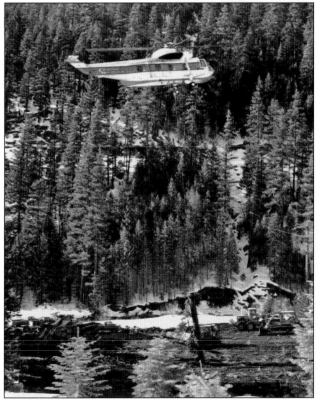

The first helicopter timber sale in the United States occurred on Lights Creek north of Indian Valley in 1971. The Plumas Lumber Company of Crescent Mills contracted Columbia Helicopters, which provided a Sikorsky S61A to fly the logs. Although extremely expensive to operate at more than $1 per second, they have the advantage of working very steep terrain and causing minimal damage to residual tree stands.

53

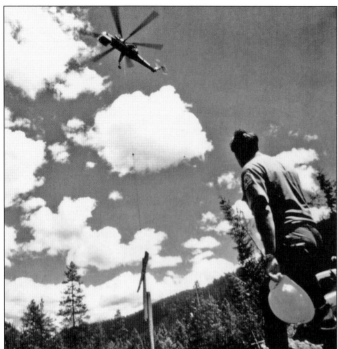

Plumas National Forest Supervisor Lloyd Britton watches from the landing as a Sikorsky owned by Evergreen Logging Company flies in a turn from the woods. Although the propeller blades look stationary, they can put down a prop wash of up to 150 miles per hour, blowing pinecones, limbs, bark, and debris onto the woods crew working under them.

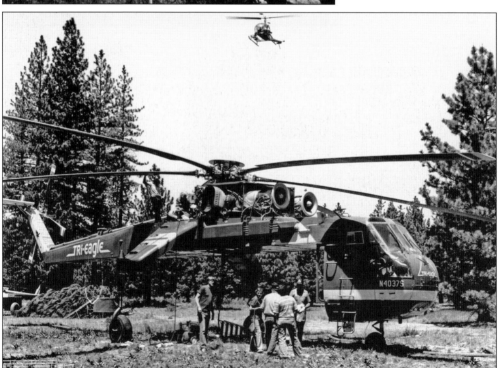

Louisiana Pacific Corporation, Siller Brothers Logging, and Evergreen Logging joined together to form Tri-Eagle Logging Company and operated on the Plumas National Forest in the late 1970s. This Sikorsky 64 is undergoing routine maintenance and fueling near Two Rivers while a small Bell helicopter used for delivering chokers and supplies to the woods crew approaches.

Five

THE LOG HAULERS

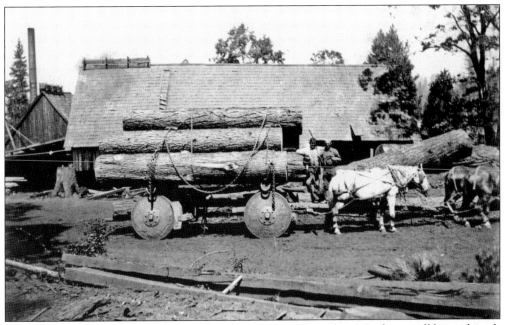

A load of logs pulled by a horse team arrives at the steam-powered McIntosh sawmill located south of the celebrated Gold Rush town of La Porte. The McIntosh family was successful in mining and lumbering ventures in southern Plumas County before branching into the hardware business in Quincy. The heavy wagons designed for moving logs were called "trucks." This one has solid wood wheels made of tree rounds pressed with iron rims. The rounds of wood were whittled by ax into a taper, being thicker at the axle hub and narrower at the rim. Use of these wagons required well-graded roads constructed with minimal gradients.

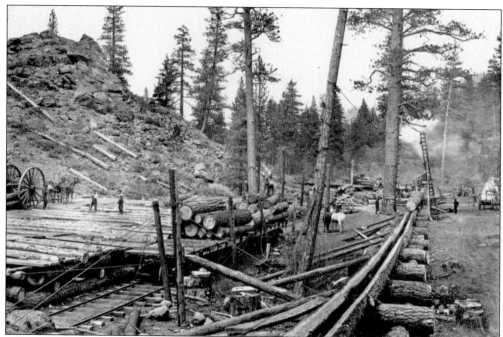

This eastern Plumas County logging operation, pictured around 1905, includes an array of features. From left are a set of horse-drawn "big wheels" with a turn of logs on an elevated log deck, a Boca and Loyalton Railroad flat car receiving logs, and an elevated and braced log chute with a steam donkey yarder at the end, where logs are being loaded for the journey by rail to the mill at Loyalton.

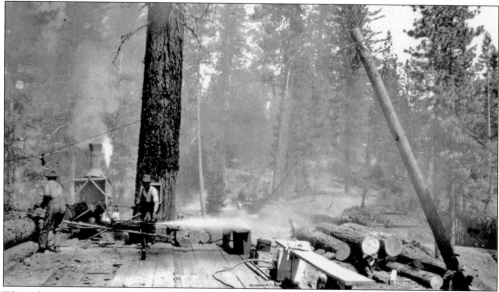

This photograph shows well the heat and fevered activity present at a Spanish Peak Lumber Company log landing above Spanish Ranch in 1920. A steam-powered drag saw is bucking the newly arrived logs to the correct length, while a steam donkey and swing pole are used for lifting the logs across to a truck being loaded to the right. The always-present oil bottle sits near the saw. (Metcalf-Fritz Collection.)

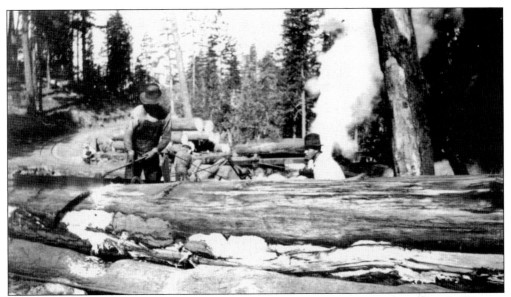

The Iceland Wood and Lumber Company began operations at Massac in 1910, just after the Western Pacific Railroad was completed. Their successor, the Massack Timber and Lumber Company, is shown in this 1921 landing view with a steam saw in operation. Pete Crook is holding the steam hose, while Bob Babb is running the saw. The small sawmill community of Massac was located about five miles east of Quincy.

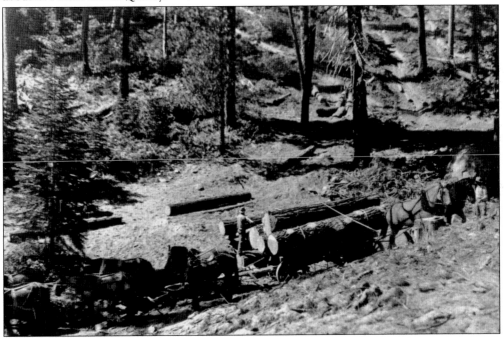

A time-tested method of loading logs onto wagons was called "cross-hauling." Horse or ox teams would simply pull a cable looped around a log and roll it up an improvised ramp up onto a wagon. Over time, steam donkeys then Caterpillar tractors often performed the same task loading rail cars or gas trucks. This particular scene was part of the Feather River Lumber Company's early operations near Delleker in 1911.

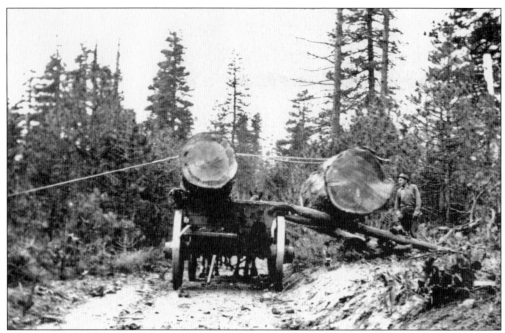

A Mohawk area logger watches closely as a large pine log is cross-haul loaded onto a wagon at a Knickrem Mill logging operation. Horses or oxen were the most common sources of power for these smaller types of loading operations. Donkey engines or steam traction engines were often employed by larger and more financially well-off outfits. (Pauly family collection.)

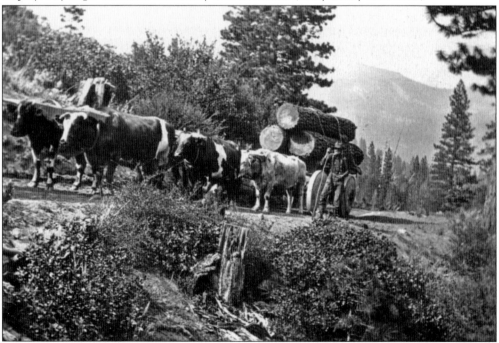

John Dow, a Mohawk area logger and teamster, walks alongside Knickrem's ox team as it hauls logs to a mill in the Mohawk Valley area around 1910. Strong but slow, oxen were popular in logging operations in the 19th and early 20th centuries. (Ruth Haddick collection.)

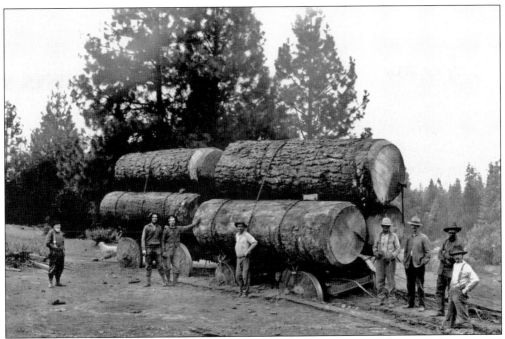

The Keith Mill wagon has foundered in mud near Clipper Mills on October 8, 1912, a wet and dreary day. The region shared by southern Plumas County, northeastern Yuba County, and eastern Butte County was blanketed with stands of enormous sugar pine, ponderosa pine, and Douglas fir. The Soper-Wheeler Lumber Company moved into this region in 1904 and is still there today. (Betty J. Boynton collection.)

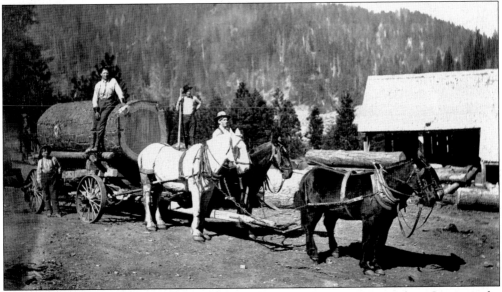

Christian Gansner partnered with H. G. Dorsch and expanded his operations from Quincy to the Spring Garden area when the Western Pacific Railroad began construction of the lumber-consuming William's Loop trestle in 1907. Located on the east side of today's Highway 70 and Squirrel Creek Road intersection, the Gansner and Dorsch Mill site later became the home of the Mason and Hager Mill. This view is to the west.

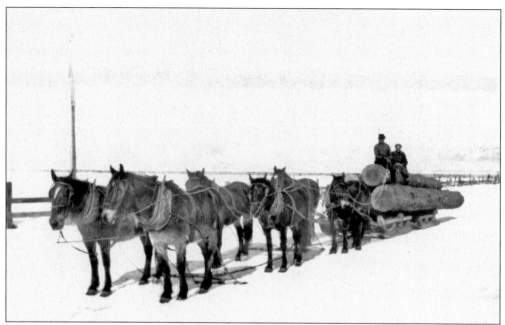

Oliver Scolari and Tony Ramelli haul a load of logs through Sierra Valley in January 1914. Although winter logging was not common in Plumas County, there were logging operations that sometimes took advantage of certain winter conditions to move logs to the mill. (Rip Scolari collection.)

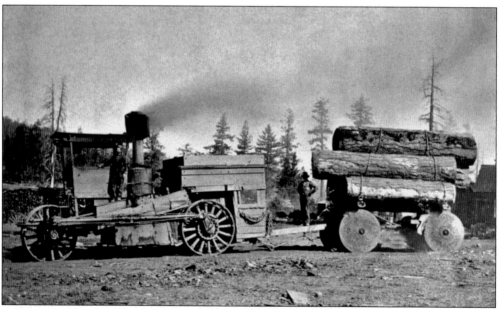

Stream tractors were one of the first attempts in replacing animal power. This remarkable Roberts and Doan steam traction engine was in use during the late 1890s, moving logs to the Lewis Mill south of Loyalton. This rare engine is rod-driven like a locomotive and delivered power to all three wheels. Its cab-forward design had the driver up front and the fireman feeding the boiler in the rear compartment. (James E. Boynton collection.)

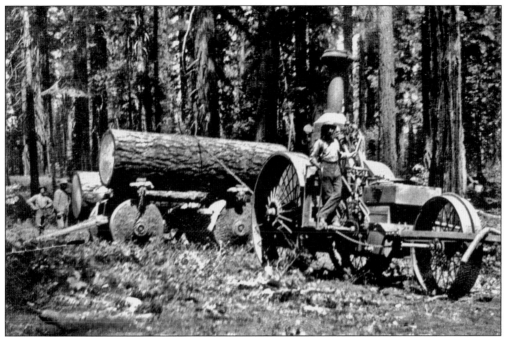

This early Holt steam traction engine is believed to have been in use on C. J. Lee's timber tract at Lee Summit, 11 miles east of Quincy. In operation by 1897, Lee's revolutionary machine was one of the earliest steam traction engines used in Plumas County. This particular logging venture was focused on high-value sugar pine. The lumber was being transported to San Francisco for export to foreign and domestic markets. (Stella Fay Miller collection.)

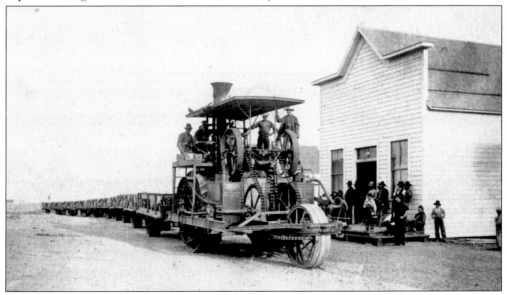

The Horton Brothers Holt traction engine stops for water in downtown Beckwith around 1900. These massive machines were very powerful and used the limbs and slash left over from logging operations for fuel but needed frequent stops for water. The Horton Brothers had a sawmill in Red Clover Valley between 1891 and 1903, when they moved their operations to Loyalton. (Williams House Museum collection.)

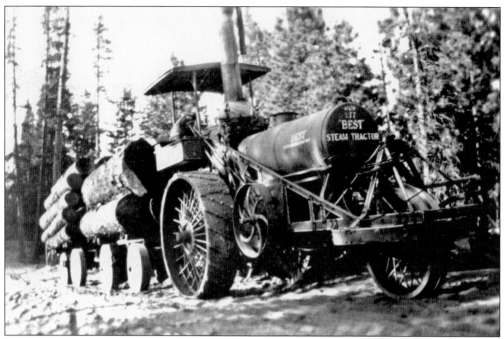

Two competing traction engine companies were prominent in Western logging operations: the Holt Company of Stockton and the Best Steam Traction Company based in San Leandro, California. While Holts were popular early on, the Best stream traction engine seems to have been the most popular in the forests of Plumas County. This Best engine is hauling two loaded log trucks to the F. S. Murphy Mill at Sloat in June 1915. (Martha Spooner collection.)

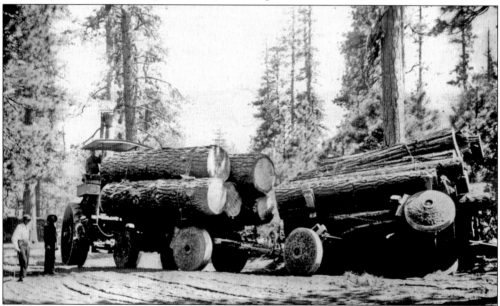

The Best traction engine shown here was hauling a couple of truckloads of logs when an axle may have broken or a soft spot in the road was encountered that resulted in the tipping of the rear truck off the side of the road. The mixed load of cedar and sugar pine has leaned over against a pine tree that is preventing the load from spilling entirely. (Jack Donnenwirth collection.)

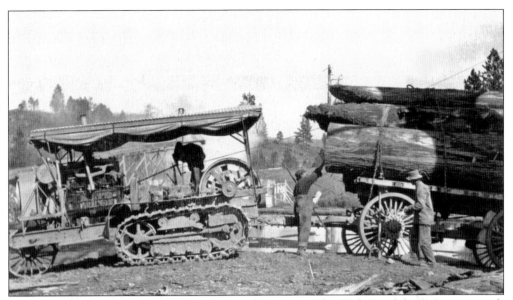

By the mid-1910s, steam was giving way to gasoline power. This Holt "track-laying" engine with its huge four-cylinder engine was a precursor to later Caterpillar tractors. Feather River Lumber Company used this workhorse at their Mill No. 3 just south of Clio in Mohawk Valley in the 1910s. It was the Holt Company that actually developed the tracked wheel design that became known as the Caterpillar. (Metcalf-Fritz Collection.)

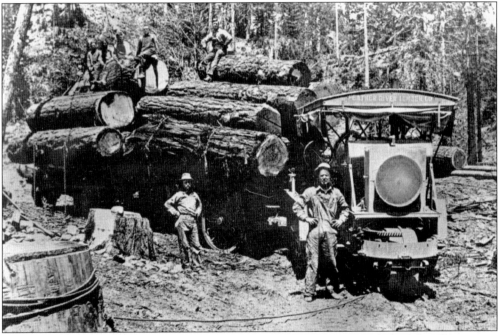

This view of the Feather River Lumber Company's Holt gas engine includes John Shipman in front and Pleas Thomas, the first man on the second load. The two trucks have just been loaded with pine and pecky cedar. The prominent circular item on the front of the engine is its radiator. The Feather River Lumber Company's Clio operation ended suddenly after a large forest fire in 1918 burned over their holdings. (L. E. Thomas collection.)

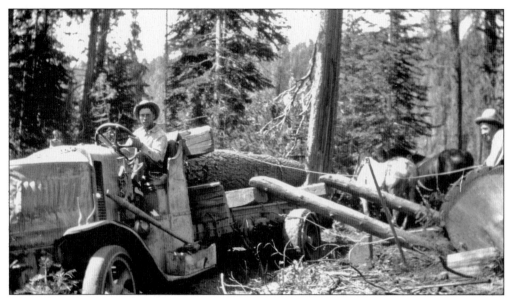

This relatively new Mack truck has already suffered battle scars during its short duration as a log hauler. The Campbell operation provided logs for the sawmill located at Walkermine during the 1920s. Although advanced in the use of log transport, the company still relied on the old-style method of cross-haul loading with animals. Ruben Olsen sits on the truck while Francis Campbell leans on the log at right. (Harriet Richards collection.)

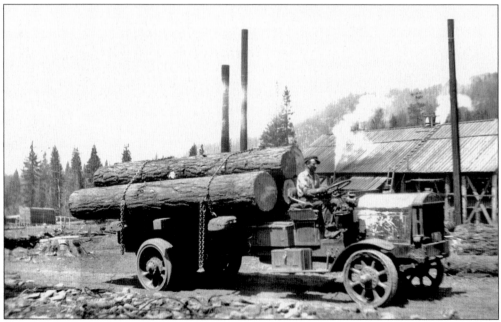

During 1918, the Engels Mining Company was horse-logging national forest timber on Lights Creek with a log chute 4,402 feet long extending to their mill. Apparently, they were also utilizing this truck to supplement the mill's logs, perhaps from nearby private timber holdings. Note the operator is seated on the left side of the cab of this unidentified make of truck.

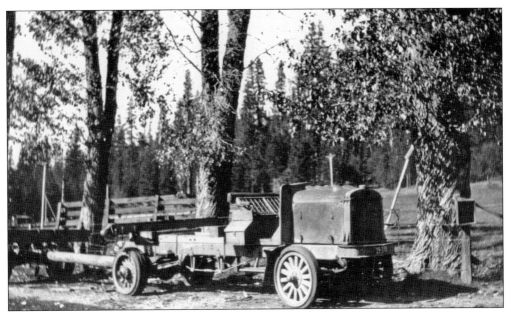

Solid rubber tires were standard equipment on early 1910s trucks such as the Towle Brothers Fageol seen at Spanish Ranch. Typical trucks were 1 to 5 tons in capacity with water-cooled, four-cylinder gas motors and three-speed transmissions. Usually chain-driven, some early models sported drive shafts.

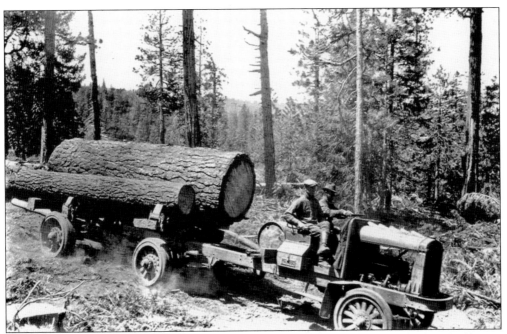

A Towle Brothers 1910 Fageol log truck is coming down a hill with an unsecured load of logs at Slate Creek, four miles west of Quincy about 1914. On the trailer bed, "cheese blocks" stabilized the logs. Braking systems were not well developed and failed frequently. It was said that open cabs persisted for so long in log trucks because it allowed drivers to jump off if their truck got away. (Metcalf-Fritz Collection.)

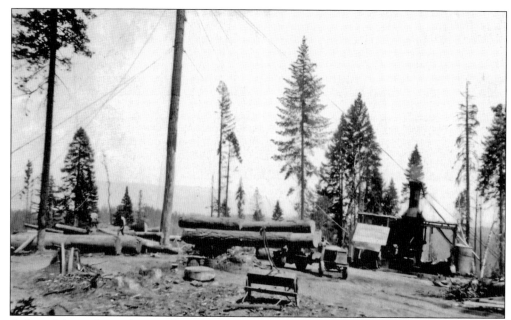

A few of the early truck manufacturers were Fageol, Kelly-Springfield, Packard, White, Mack, and GMC. As with tractors, World War I spurred improvements in truck design. Following the war, trucks became common in Plumas County logging operations. This view of a Spanish Peak Lumber Company landing shows a Fageol truck and trailer being loaded by a steam donkey in 1925. The swiveling fifth wheel allowed sharp turns and long logs. (Metcalf-Fritz Collection.)

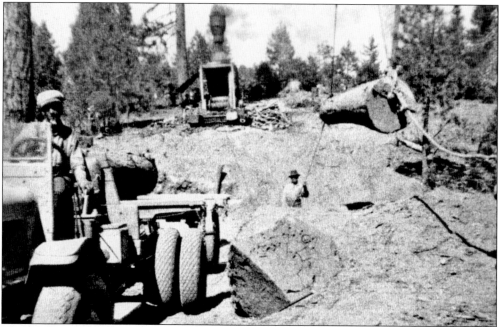

This truck at a Spanish Peak Lumber Company landing in the late 1920s has evolved to pneumatic tires but still has the open cab. Additionally, there are dual wheels on the rear and the trailer, allowing heavier loads. By the 1930s, diesel engines had begun to replace gasoline engines and braking systems were greatly improved. (Metcalf-Fritz Collection.)

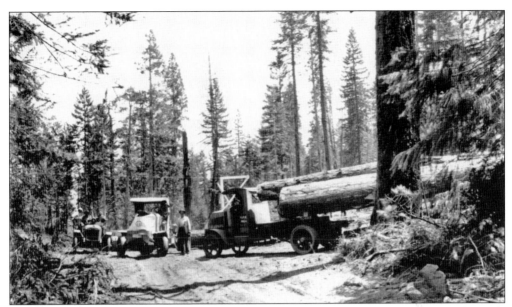

Two California Fruit Exchange Mack Bulldog trucks meet at a mechanical stop sign near Graeagle in the mid-1920s. The Mack Company managed to weather the Great Depression. The popular Bulldog actually had a longer production run than Ford's Model T, being manufactured from 1916 to 1938. The unique sloped-nose look of the Bulldog was due to its rear-facing radiator. An early Republic truck is at left. (Debbie De Selle collection.)

Loggers were not afraid to use their equipment and trucks for all they were worth as these Davies Lumber Company men demonstrate in the 1930s. These oversize loads were not allowed on public roads, which at that time were of far lower quality than today. By the 1950s, trucks with huge loads of logs rolling along private roads paralleling public highways were a common sight, particularly near Chester.

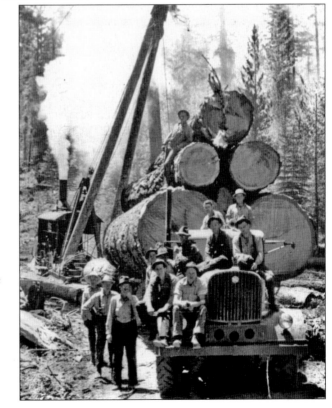

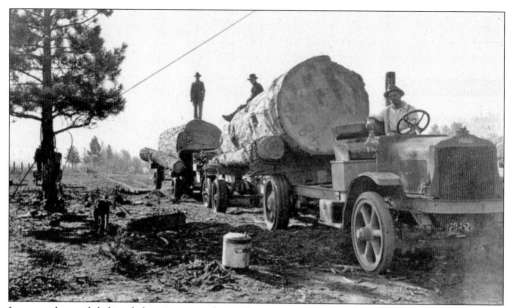

Log truck availability fed a rise in independent contractors or "gyppo" loggers. With basic equipment, gyppos could contract their services to larger timber companies and mills. Portola gyppo Ed Lane ran a logging job for Feather River Lumber Company at Burnham Meadows near Portola in 1920. During the Great Depression of the 1930s, there was a significant rise in gyppo loggers as men looked everywhere for work. (Ray C. Donnenwirth collection.)

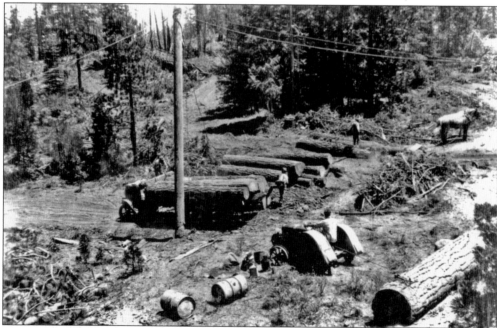

The Maxwell Brothers Logging Company operation near Portola is shown here about 1925. A small agricultural tractor without benefit of rollover protection has been pressed into service to skid in logs to the landing. A cleat tractor (not shown) is hooked to the spar tree or "gin pole" to load the truck, while nearby a horse team stands patiently waiting to return for another turn. (Thomas Maxwell collection.)

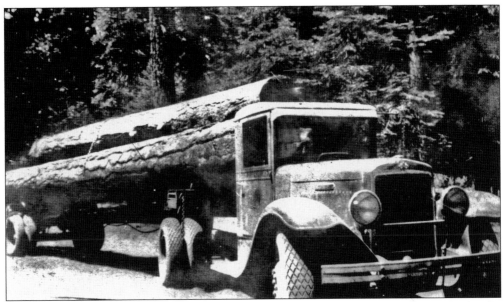

This is a 1942 view of Cephus W. Detrick's Diamond T log truck. After a stint as a bucker for George Howell Logging, Detrick hauled logs and maintained roads for Frank Redkey and Wardlow Howell Logging Company from 1942 to 1952. Cephus's son Derald Detrick, of Quincy, began hauling logs in 1956 with his own truck for various logging outfits and is still doing so at age 76. (Ethel Howell collection.)

One gyppo logger who went on to form several logging companies and successfully operate on through to retirement was Al Olds. The information on this photograph indicates that Al is shown at Massac with his truck sometime in the early 1950s. The battered truck was one he took with him when he parted with Trio Logging Company in Taylorsville. (Mary Lynn Neer collection.)

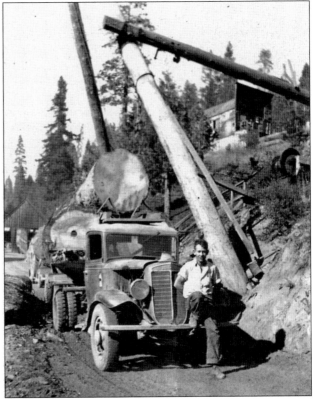

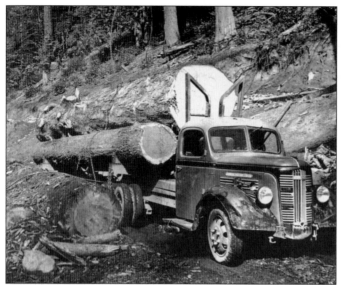

The Swayne Lumber Company of Oroville logged in the Granite Basin just west of Bucks Lake and into the Little North Fork Feather River region. This 1938 shot shows a somewhat battered 1937 GMC being unloaded at a transfer landing where the logs will be placed on railroad cars for their trip to Oroville. Clover Valley Lumber Company of Loyalton also practiced similar transfers, allowing oversize loads on the trucks. (Paul Beckstrom and David Braun collection.)

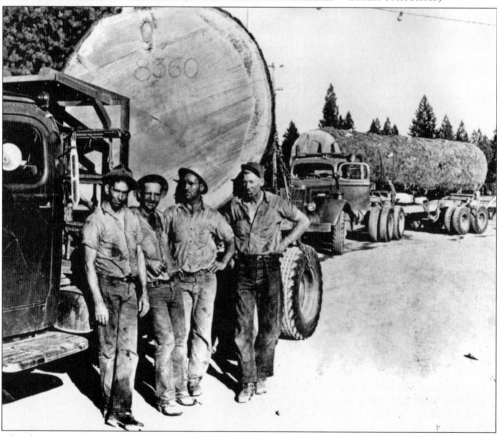

This huge ponderosa pine from near Grizzly Forebay was one of two logs featured in the 1949 Plumas County Fair parade. From left to right, proud loggers Ben Pauly, Vic "Bus" Egbert and Chris Egbert (brothers and logging company owners), and Bob Lowrey I pose for the camera. The two logs seen here contained more than 8,000 board feet each. (Bob Lowrey II collection.)

This 1952 Plumas County Fair parade shot is of the largest log ever sent through the Quincy Lumber Company's Sloat Sawmill. A sugar pine at 11,240 board feet, it produced the equivalent of enough lumber to build an entire house with some left over. (Mary Ann Pruitt collection.)

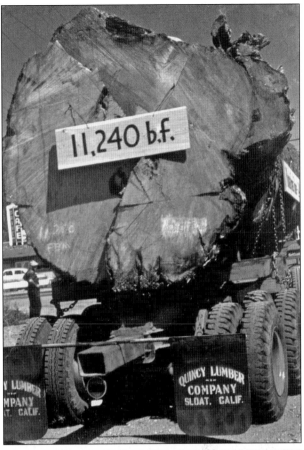

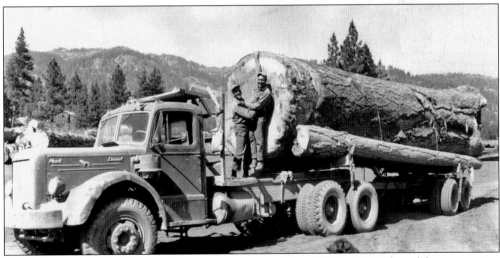

Orville Brown hoists Al Maunder up against the small end of the 11,240-board-foot sugar pine cut on Silver Creek, near Nelson Creek, in 1952. Whereas 30 years before it was considered uneconomical to build a road 20 miles into the woods, by the early 1950s, the lumber companies, with U.S. Forest Service assistance, were punching roads into untouched remote areas where stands of these ancient behemoths stood for centuries. (Orville Brown collection.)

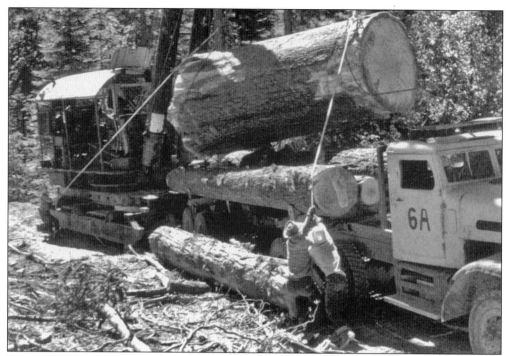

Soper–Wheeler Company of Strawberry Valley, south of La Porte, has been logging and tree farming in Plumas County since 1904. In this late-1950s photograph, their shovel loader strains with the help of three men to load a massive 16-foot sugar pine butt onto a Sacramento Box Factory truck. (Soper-Wheeler Lumber Company Collection.)

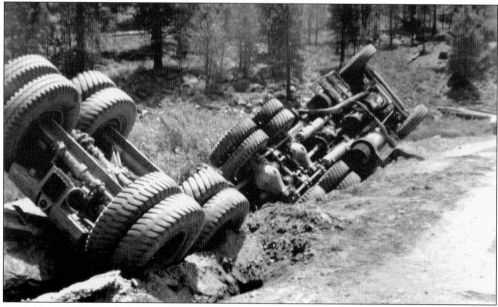

Truck No. 31 of Clover Valley Lumber Company tipped over at the Last Chance Creek Bridge in 1957. According to LaVerne Diltz, as he approached the middle of the bridge with a full load, "the next thing I knew was the left side of the bridge collapsed and over the truck went." These off-road trucks could haul two to three times the board feet of a highway truck. (Susan Haren collection.)

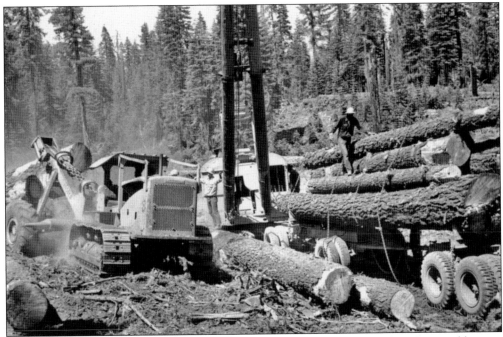

This 1950s photograph shows a Collins Pine bald face D8 Caterpillar with a Hyster rubber tire arch bringing in a hefty skid to a shovel loader landing. The top loader, who is probably also the truck driver, is straightening his binders over the load before tightening them.

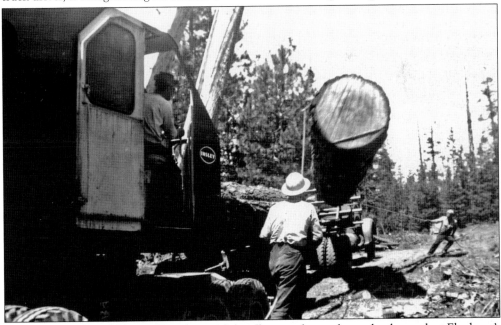

Si Brand, at right, and Loren Kingdon, with hardhat, work together to load a truck at Elephant's Playground east of Indian Creek on the way to what is now Antelope Lake. The L. H. Brand Logging Company, owned by Si Brand, logged Elephant's Playground in 1954, hauling the oversized loads to the nearby Genesee Mill. The interesting place name was for the enormous granite boulders resembling elephants. (Loren Kingdon collection.)

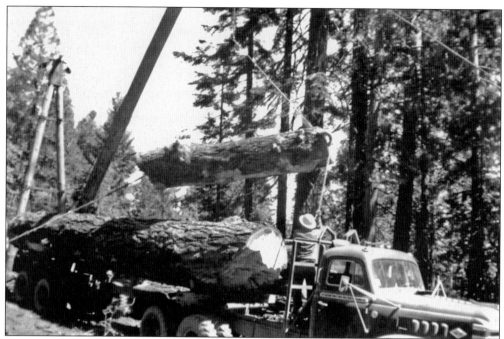

Trio Logging Company of Taylorsville operated out of the Kettle Rock area during the mid-1950s when this photograph of their A-frame loader and Diamond T truck was taken. Brothers Robert and Grobner Williams designed and built the swing pole attached to the loader to make it easier to load large logs. The Diamond T's had propane-powered 590 Hall-Scott engines and were well suited to their rigorous hauling jobs. (Robert Williams collection.)

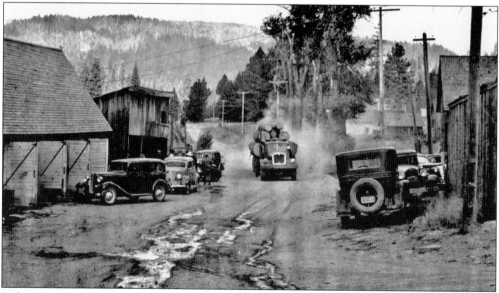

In late August 1940, a number of loggers working for the Maxwell Brothers Logging Company went on strike for higher pay and better working conditions. Maxwell Brothers, contractors to Meadow Valley Lumber Company, resisted the strike, and in early September 1940, one of their heavily laden log trucks drove through the picket line to the mill. After negotiations with the AFL and the CIO unions, the matter was resolved.

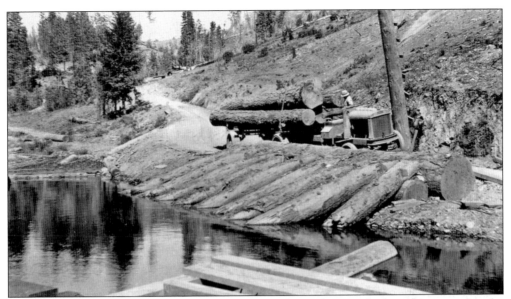

Unloading logs at the millpond consisted of pulling the truck up to the brow log situated under a swing pole or other loading device. The load was wrapped with the loader's cable to secure it, the binders released, and the logs lifted off the truck and rolled into the water. This 1925 shot shows a Spanish Peak Lumber Company truck readying for unloading with a swing pole at their mill. (Dan Baldwin collection.)

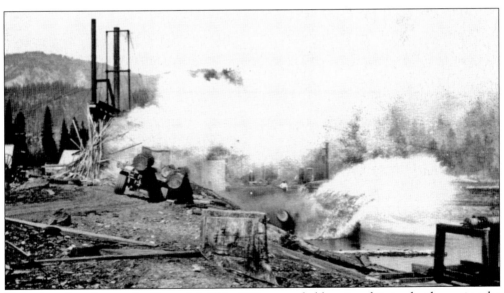

Unloading these logs at the Graeagle Mill in 1921 was probably quite a bit simpler than using the swing pole method. After removing the cables securing the load and knocking out the "cheese blocks," the driver jumps out of the way and the logs roll off the truck and into the pond. (Rob Wood collection.)

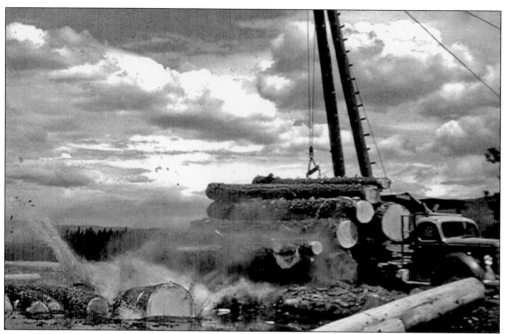

Twenty years later, unloading logs was still basically the same procedure as it was at Spanish Ranch and Graeagle in the 1920s. In this 1940s view at the Quincy Lumber Company mill in Quincy, a truck is being unloaded with a wood-frame shovel loader.

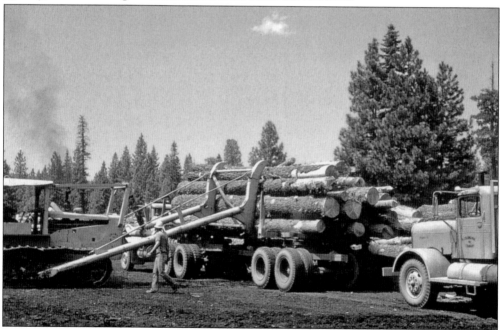

Over time, mobile unloading methods were employed, particularly when a millpond was no longer in use, and as faster truck turnaround times were desired. This Caterpillar with modified forks unloads logs at the Collins Pine Mill in Chester in the late 1960s or early 1970s. It was not particularly a favorite with truck drivers, as it was prone to scattering logs and tearing off lights and mud flaps.

Six

THE RAILROADS

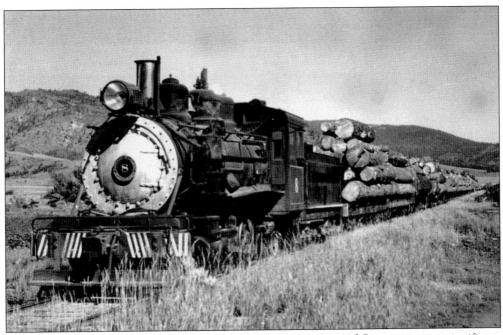

Perhaps no other technological advancement in the western United States was more significant in the transport of logs than railroads. Beginning in the late 1870s, rails were laid into the mountains of the Sierra Nevada, but in Plumas County, this development was delayed until the very end of the 19th century. Once it began, however, particularly after the completion of the Western Pacific in late 1909, railroad logging in Plumas County grew significantly. Shown here in 1956 is Clover Valley Lumber Company's No. 8 Baldwin 2-6-2 locomotive toward the end of its employment with the company, which ceased rail operations in 1957. The train was on its way to Loyalton with a full load of logs. Clover Valley Lumber Company trains could haul up to 250,000 board feet per day to the mill.

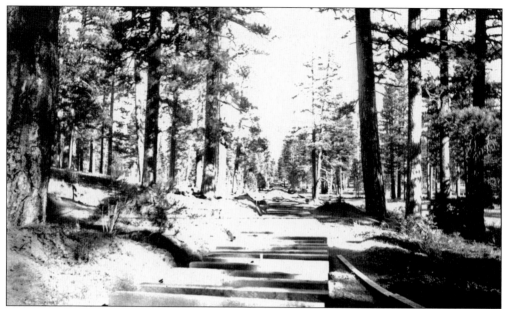

The Sierra Valleys Railway, first known as the Sierra Valley and Mohawk Railroad, was Plumas County's first railroad. It crossed Beckwourth Pass into Sierra Valley in 1885 and reached the town of Clairville by 1895. While it was a common carrier, this cash-strapped narrow-gauge operation hauled logs at every opportunity. Here a section of right-of-way is under construction between Clairville and Clio in Mohawk Valley in 1903. (Vinton Bowen White collection.)

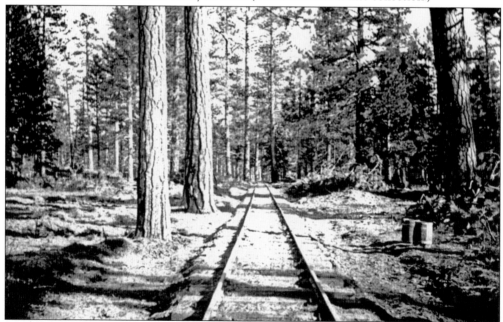

Narrow-gauge railroads could be constructed rather quickly and inexpensively. With only three feet between the rails, these lines could take tighter curves and steeper grades, which was ideal for the challenging terrain of the northern Sierra Nevada. These new tracks near Clairville were placed on level ground using untreated ties on a raised bed consisting of the surrounding soil. (Nevada State Historical Society Collection.)

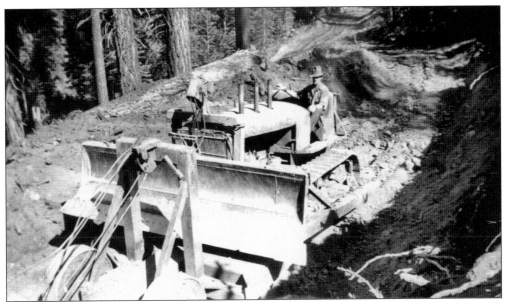

In the early years, railroads were built using horse-drawn Fresno-type scrapers, black powder, and picks and shovels. When tractors were perfected for woods work in the 1920s, they soon found their place building railroad grade. Red Savage is shown running a Caterpillar tractor to build rail bed for Clover Valley Lumber Company in Squaw Queen Valley in 1935. (Don Johns Sr. collection.)

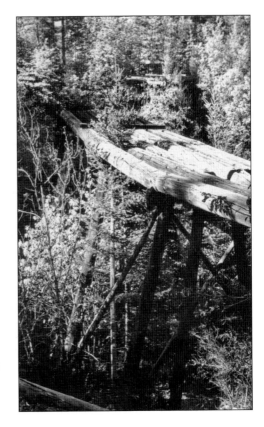

Many of the trestles built for railroad logging were engineering marvels. Plumas County railroad logging systems had their share. Here one of the trestles installed on the Quincy Lumber Company's railroad is shown standing in the Butterfly Valley area in the mid-1960s. This trestle was in use during the late 1920s. (James E. Boynton collection.)

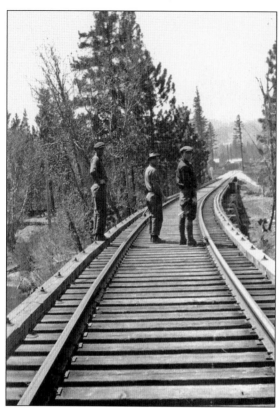

This early 1920s view is west toward Graeagle from the California Fruit Exchange's rail spur bridge across the Middle Fork Feather River, connecting their plant to Blairsden and the Western Pacific Railroad. The California Fruit Exchange ran rails east into the Sulphur Creek area and northwest along the Middle Fork Feather River toward Two Rivers. (Rob Wood collection.)

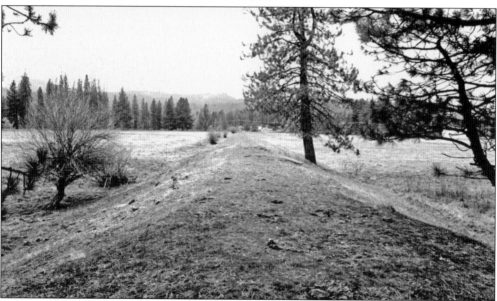

The sawn-off stumps of the old pilings for the former trestle can still be seen in the Middle Fork Feather River just upstream from the Denten Bridge leading from Blairsden to Graeagle. This 2004 view shows the old raised bed of the grade just south of the river running toward what used to be the California Fruit Exchange sawmill in Graeagle. It is the same grade seen in the distance in the photograph above.

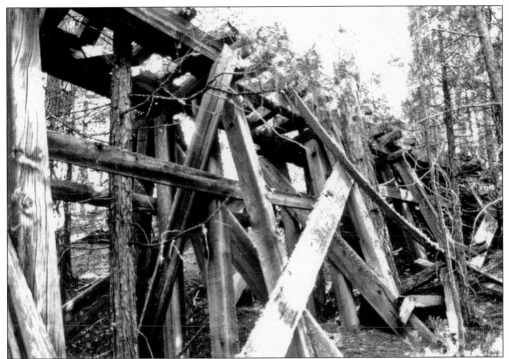

These narrow-gauge trestle remains of the F. S. Murphy logging railroad north of Lee Summit were in use about 1918. Most of these spans were left behind when logging was finished, merely to fall and rot on the forest floor. Here the trees growing up through the trestle now help support this fragile feature. Standing trestles are now few and far between.

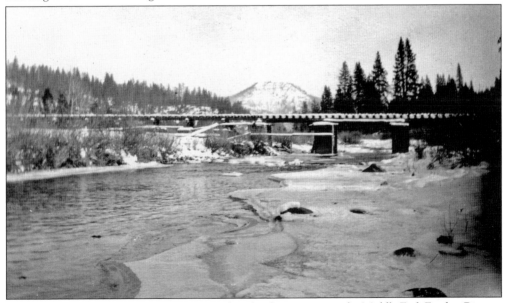

The F. S. Murphy Company narrow-gauge railroad is shown crossing the Middle Fork Feather River at Sloat where it extended to Poplar Valley. This bridge was in use between 1923 and 1929. The Murphy narrow-gauge railroad was only 30 inches wide rather than the usual 36 inches (3 feet), due to the company's use of secondhand equipment. In 1936, the entire railroad system was abandoned.

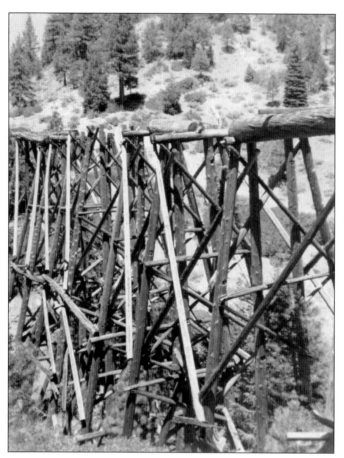

One of the most impressive railroad logging trestles in eastern Plumas County crossed Barry Creek, a tributary of Sulphur Creek above Mohawk Valley. The California Fruit Exchange began constructing a standard-gauge logging railroad in 1924 with this span in place not long afterward. Imagine guiding the company's 54-ton Baldwin locomotive with several carloads of logs across this span. Those on the train would not be able to seen the bridge as they were crossing it. These two photographs taken in the 1960s show the trestle in an advanced state of decay. The view to left shows some of the decking still on top of the trestle while the view below shows only a few of the piers still standing. Today the Barry Creek trestle is no more than a pile of rotting logs in the gully.

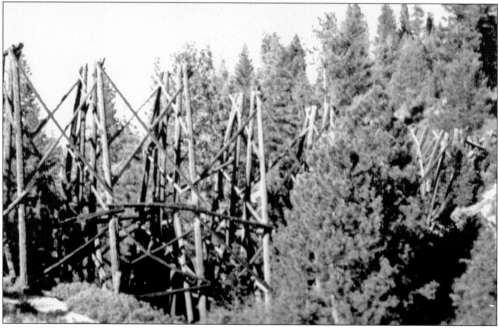

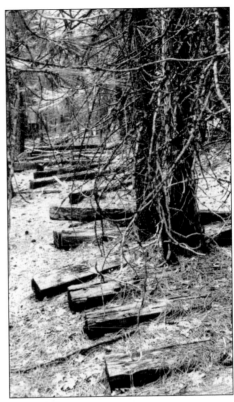

Along with the rotting trestles, the old rail beds themselves can often still be observed in the forests of Plumas County. Remnants of the old rail beds include cuts in the hillsides and fills in some of the seasonal ravines. In many cases, the ties were left behind to rot. Rails were always reused or, when railroad operations were terminated, the rails themselves had value for scrap at the very least. To the right, a segment of the Massack Timber and Lumber Company's narrow gauge is becoming overgrown but was still apparent in the mid-1980s. Below a length of the California Fruit Exchange standard-gauge grade with the ties still in place is quite obvious near White Hawk Ranch in Mohawk Valley in 2007. (Plumas National Forest Collection.)

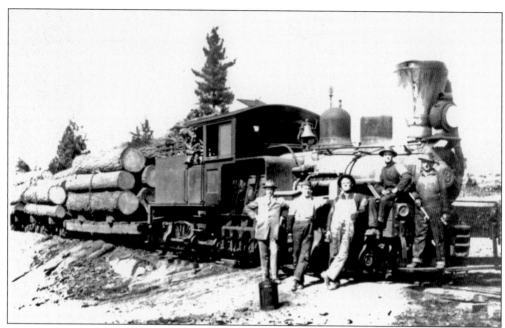

One of the major players in eastern Plumas County railroad logging was the Feather River Lumber Company. Around 1915, they began railroad logging operations using geared Shay locomotives. Here company president George Laws, shown to the left, poses with the engine crew in front their No. 3 logging engine in the late 1910s at Delleker.

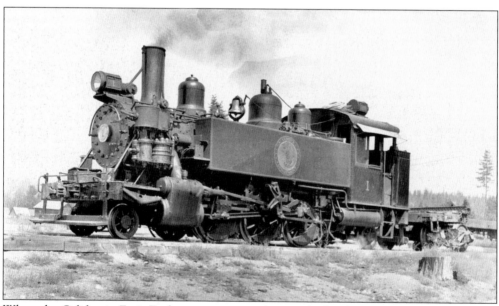

When the California Fruit Exchange constructed a standard railroad system in 1924, it also purchased a brand new, rod-driven Baldwin 2-6-2T saddle tanker. It is shown here in 1934 as No. 1. The Blue Anchor fruit box logo was prominent on the sides of the tank. When rail operations were terminated in 1938, the engine went to the California Western Railroad at Fort Bragg. It still exists in Mendocino County.

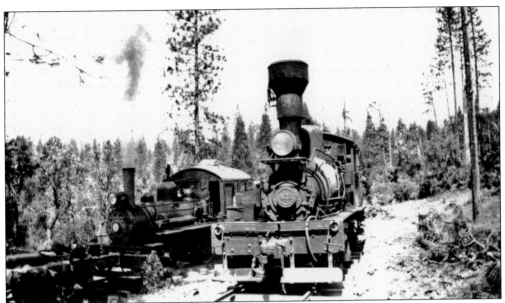

Many companies used both rod- and gear-driven locomotives. This was true of the Quincy Lumber Company. This photograph shows their Engine No. 1, a 0-4-4T Alco on the left and Engine No. 422, a two-truck geared Shay at a switchback in the Butterfly Valley area in 1927. The company chose to retain the number 422 designated by the engine's former owners and was one of four locomotives in operation.

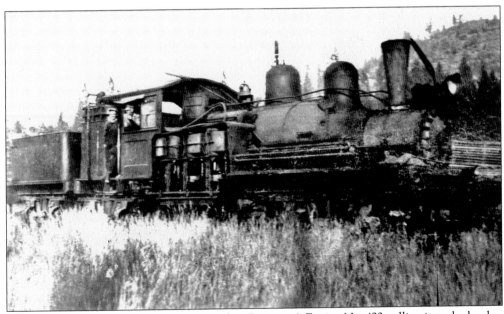

Shown here is another view of Quincy Lumber Company's Engine No. 422 pulling into the lumber mill that was once located at today's Plumas Pines Shopping Center in Quincy. Shay locomotives were the engines of choice for many Plumas County railroad logging operations. The gears were designed to deliver power to all the wheels. They were slower than traditional rod-driven engines but were very powerful. (Tish Whipple collection)

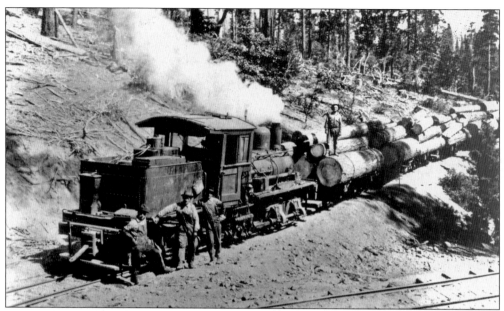

Sloat Lumber Company's Engine No. 2 is shown here on its 30-inch-gauge railroad in the Poplar Valley area, south of Sloat and the Middle Fork Feather River around 1923. The Shay engine was built by Lima Locomotive Works of Ohio in 1907 and came to Sloat in August 1917 from the Empire City Railroad near Tuolumne, California. It was scrapped at Sloat in 1937.

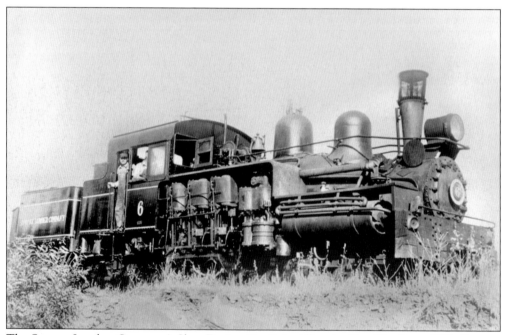

The Swayne Lumber Company's Shay Engine No. 6 sits idling in Oroville. Since 1918, Swayne was western Plumas County's major railroad logger. The company operated out of Oroville into the 1930s, extending rails into the lower reaches of the Middle Fork Feather River and as far as Granite Basin. This Shay is a large one, weighing in at approximately 57 tons. It is the only Plumas County Shay engine that survives.

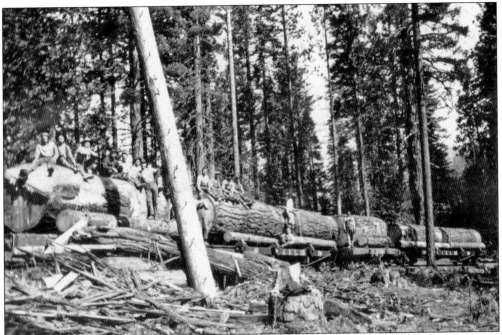

The M. J. Scanlon Lumber Company succeeded the Massack Timber and Lumber Company in 1923 and operated out of the mill at Massac until 1938. This impressive view shows their crew atop huge logs on recently loaded cars. In front is the swing pole used in loading the logs. The man on the far right marked with an X is identified as "Mack."

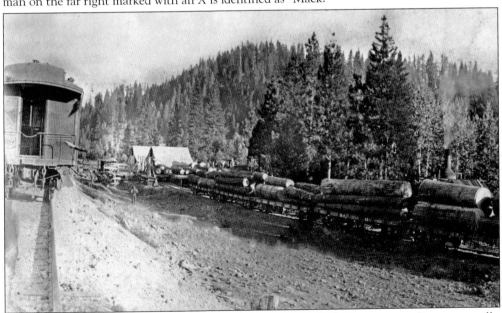

Some operations hauled logs to sidings on the Western Pacific for transport to distant sawmills. The California White Pine Lumber Company was shipping their logs on the Western Pacific, shown here in 1911, only two short years after the line was completed through the county. The flat cars loaded with logs in this view facing east were destined for their mill in Logalton. The Langhorst Ranch barns at Cromberg are pictured in the background.

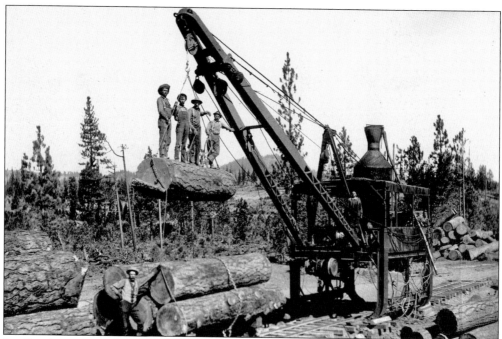

Loading logs onto rail cars was accomplished with the use of steam power. The McGiffert Log Loader, seen here, was made by the Clyde Iron Works of Duluth, Minnesota. These mobile booms were also known as "jammers." At first, many were fired by wood but, like the locomotives in the 1920s, were converted to burn oil. This is the Feather River Lumber Company's jammer with its showboat crew.

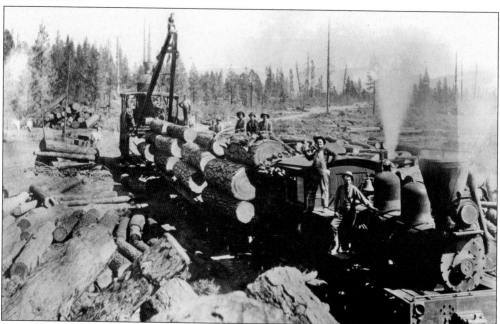

Feather River Lumber Company's No. 3 Shay is loaded and ready to pull away from a log landing and the jammer near Delleker, about 1916. The workers were obviously enthusiastic about having their picture taken. Note the daredevil on top of the loading boom left of center.

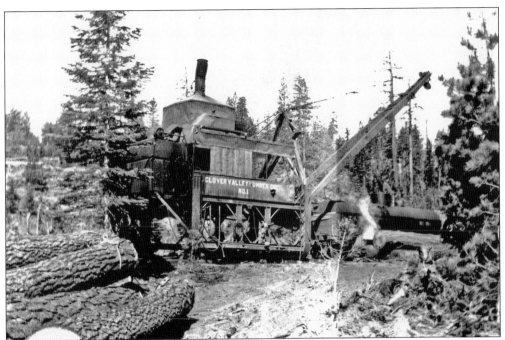

William "Bill" Diltz, Marcel Bony, and Huey O'Connor came with the Verdi Lumber Company's two jammers to the Clover Valley Lumber Company in the mid-1920s. The two McGiffert loaders were used for decades, right up to the end of railroad logging operations. A more efficient portable boom could simply not be contrived. Here No. 1 is taking on fuel from an oil tanker car. (Susan Haren collection.)

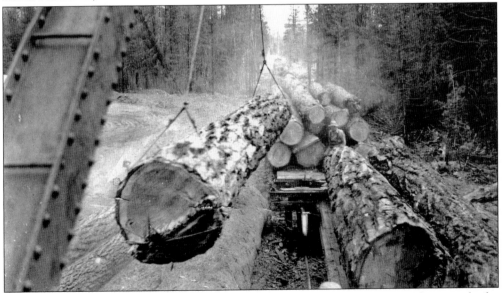

This is the loader operator's view of Clover Valley Lumber Company's train from inside the jammer. The jammer would travel along the railroad then straddle the tracks at a landing. Empty flat cars were pushed through, positioning them one after the other beneath the boom. As each was loaded, they were pulled forward until the string of cars was loaded and ready for the trip to the mill. (Susan Haren collection.)

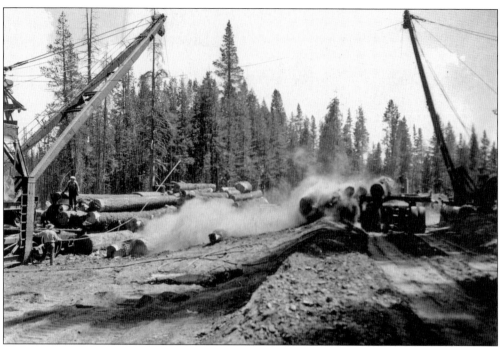

This transfer landing in Squaw Queen Valley was indicative of changing transportation methods. Trucks now brought logs in from the cutting areas to landings, where they were transferred onto railcars. Because Clover Valley Lumber Company operated many miles north of the company mill in Loyalton, the railroad continued to be the most economic means of log transport from the woods to the mill.

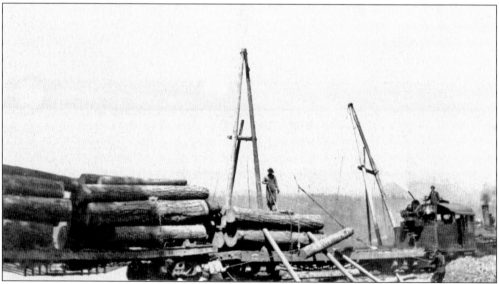

During the 1916–1917 season, Quincy Lumber Company was busy logging the mountain sides south of the Meadow Valley Road about two miles west of Quincy. These logs are being loaded with a winch and A-frames onto flat cars using the locomotive's steam as a source of power. The lumber company's mile-and-a-half extension off the Quincy Western Railway was completed in late November 1916.

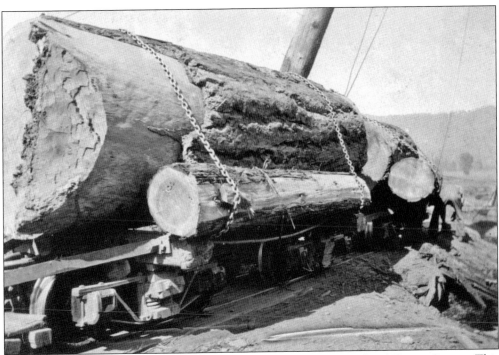

Flat cars were the typical means of transporting logs by rail to the mills of Plumas County. This huge Douglas fir butt has arrived at the Sloat Lumber Company's sawmill from the nearby woods. Note the undercut axe marks on the end of the log.

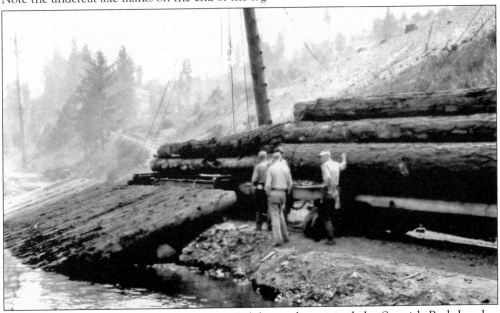

University of California Berkeley's Camp Califorest class visited the Spanish Peak Lumber Company on an educational tour in 1926 and watched the flatcars being unloaded at the millpond. This railroad was constructed in 1925 to replace the Fageol trucks in use the previous five years. The Spanish Peak Lumber Company's narrow gauge was the last all-new railroad system to be constructed in Plumas County. Note the load was pushed in. (Metcalf-Fritz Collection.)

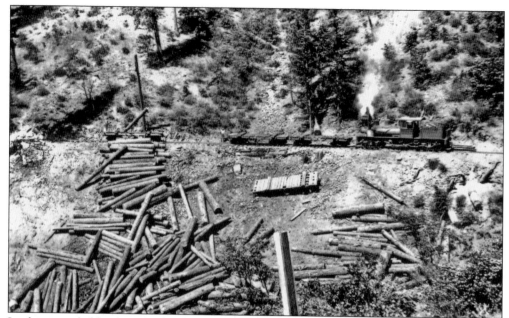

In this remarkable photograph taken around 1920, Massack Timber and Lumber Company's Shay engine, acquired from the Feather River Lumber Company, is moving downhill car by car past the gin pole that swings the logs over the side where the logs are collected and fed into the mill. Note the flat car that went over the side. The company was not in any particular hurry to retrieve it. (Metcalf-Fritz Collection.)

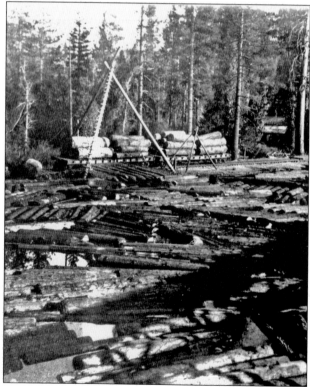

Two Western Pacific flat cars with two sets each of 16-foot logs are ready for unloading at the California Fruit Exchange Company millpond at Graeagle. Note the tripod hoist system that was used to lift the logs from the cars and onto the pond deck as they pulled beneath it. This view is east across the pond from today's Highway 89. (Debbie DeSelle collection.)

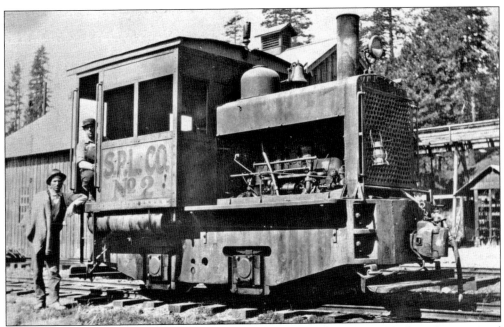

Spanish Peak Lumber Company's railroad operation was unique in its use of gasoline-powered engines. They began railroad logging with their first Whitcomb narrow-gauge engine in August 1925. By June 1926, the company had added Engine No. 2 to the roster. Rails were laid north above Spanish Ranch in the Pineleaf Creek drainages and to the northeast around Wapaunsie Creek, Whitlock Ravine, and Snake Lake. (Dan Baldwin collection.)

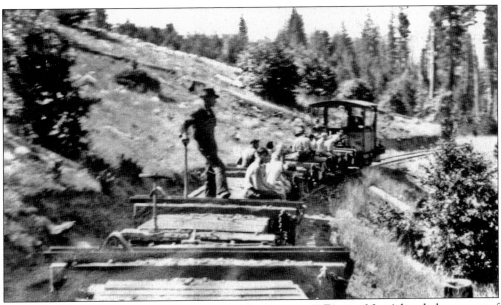

On August 8, 1930, the Spanish Peak Lumber Company's Engine No. 1 headed east out of Spanish Ranch along the Spanish Creek right-of-way to Whitlock Ravine and the Snake Lake region. Members from the Camp Califorest class in Meadow Valley are catching a ride out to the logging operations going on there. By 1933, the company went bankrupt, and the two engines were soon sold. (Metcalf-Fritz Collection.)

Spanish Peak Lumber Company No. 2 was converted to standard gauge and spent years in Nevada and the San Francisco Bay area. It saw use during World War II at the Alameda Naval Air Station. Later it came into the possession of the Bay Area Railway Museum in Rio Vista, California. In early 2001, the Plumas County Museum received Engine No. 2 as a donation, and it returned to Plumas County.

After five years and 6,000 hours of donated labor and materials, the Spanish Peak Lumber Company No. 2 is in running condition. Right-of-way has been surveyed along the mountainside at the Plumas County Fairgrounds to accommodate a five-eighths-mile, narrow-gauge loop for visitors to ride. From left to right are Sandy Coots, Ken Meyers, Jay Ricks, Clay Johnson, and Chris Coen. See the acknowledgments for the rest of the crew not shown.

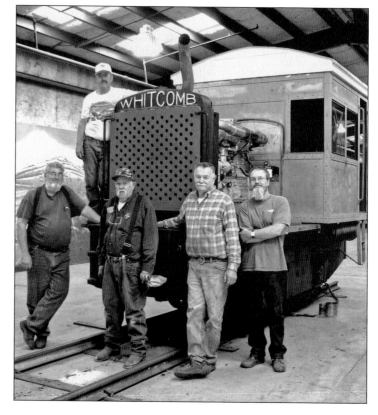

Clover Valley Lumber Company's Engine No. 4 stops for water on its way to Loyalton in 1957. The company was sold the year before to the Feather River Lumber Company, which had re-lettered their name on the engine. The Feather River Company, not to be confused with the older operation out of Delleker, shut down the railroad that same year, bringing the era of railroad logging in Plumas County to an end.

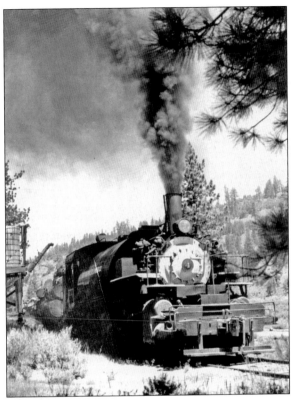

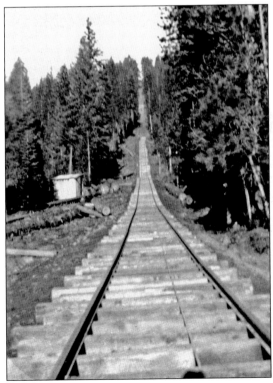

Quincy Lumber Company and the Nibley-Stoddard Lumber Company at Cromberg were the only two operations to use inclines in Plumas County. Nibley-Stoddard's incline is seen here in 1924. Empty cars were raised, and loaded cars were lowered using cables. At the top, a standard-gauge railroad extended for 10 miles. Traces of the incline can still be seen near Mt. Tomba Inn. Nibley-Stoddard's mill burned in 1928. (Ruth Haddick collection.)

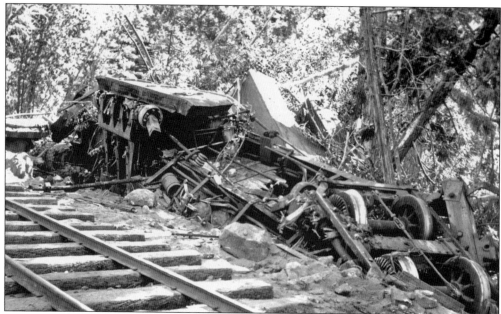

Railroad logging was not without risks. When Engineer John Wade Fuller left for Grizzly Valley on July 2, 1939, in Feather River Lumber Company's Engine No. 1, he had no idea it would be his last trip. The Shay was the company's first engine, acquired in 1914. Four miles north of Delleker, the train jumped the track, killing Fuller. His body was extricated by chopping a hole through the floor of the cab.

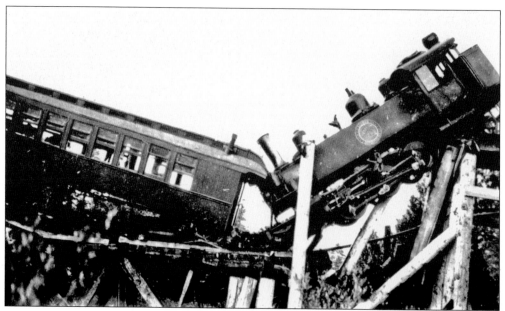

Seventeen of the 50 or so employees en route to the woods on this California Fruit Exchange train were injured when it broke through the Howe truss bridge that crossed the Middle Fork Feather River east of Clio. This rather severe looking accident occurred July 23, 1931. It was only a couple of weeks before it was repaired, and trains were once again running to the woods.

Seven

LOGGERS AND LOGGING CAMP LIFE

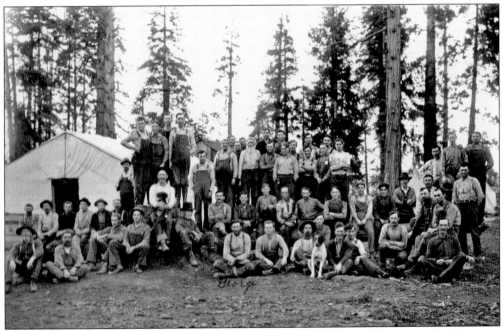

Except for George McInturff (center of the first row), these California White Pine Lumber Company workers are unidentified. Photographed near Cromberg about 1910, this group is representative of the large crews that were very common in the logging industry at this time. Everything from timber fallers, donkey engineers, choker setters, to a good camp cook was required for these operations to be successful. Many of these men were transient, finding woods work through the season and leaving for other areas in the off-season. Others were local men with families who remained year-round and found whatever work was available. Keeping dogs as pets was a common practice in the camps.

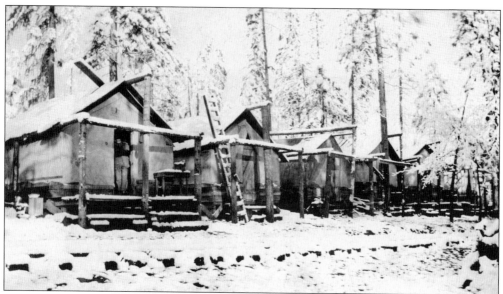

Massack Timber and Lumber Company operated several camps a few miles north of its mill. On June 21, 1921, a late snowstorm visited this camp, blanketing it and the railroad with a white mantle. The temporary housing consists of wood-frame and canvas cabins that were easily dismantled and moved to other locations. By November 12, 1921, the company, employing 50 men, had cut 4 million feet of timber.

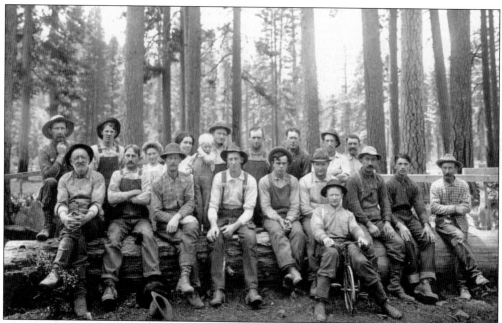

The Metcalf Mill crew of Cromberg poses for this 1912 photograph. Crew members are identified from left to right as follows: (first row) Manfred Peter Beever, unidentified, Jim Young, ? Cook, Horace Wilson, and William Metcalf; (second row) Bill Day, Lester Haddick, unidentified woman, Annie Otis Metcalf, Wilburn Edward Metcalf (child), Edward Thomas Metcalf, unidentified, Dan Stinchfield, and two unidentified people. The others, including the man on tricycle, are unidentified. (William Metcalf Collection.)

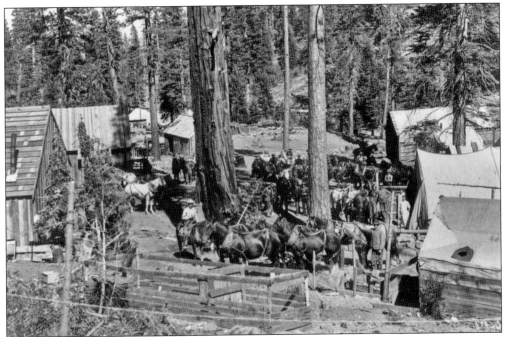

This California White Pine Lumber Company camp shows some relative permanency as indicated by the frame-board buildings and the somewhat spare but comfortable housing. There are also framed tents serving as residences. Note the chicken coop in the foreground. At the right by the tent is a man in an apron that may well be the camp cook.

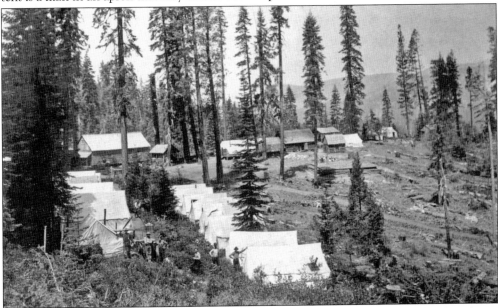

This large logging camp shows a number of canvas residences set in two rows. Behind are larger frame-board buildings as well as at least three log cabins. One of these, just right of center, is a low structure with a flat roof that may have been a dugout used for cold storage. This unidentified camp scene photographed around 1910 was probably associated with the California White Pine Lumber Company.

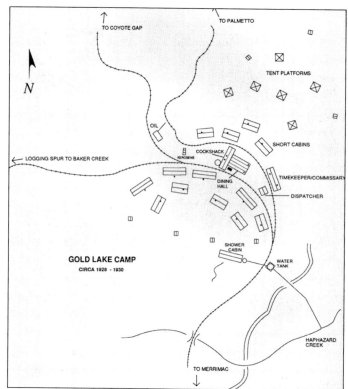

From 1919 up until 1938, the Swayne Lumber Company ran many miles of narrow-gauge railroad and established numerous logging camps between the South Fork and the Middle Fork Feather rivers. Swayne's Gold Lake Camp, in use between 1928 and 1930, represents a typical camp layout. Cookhouses and commissaries were generally close to the primary access road or railroad for ease in restocking provisions and fuel. (Paul Beckstrom and David Braun collection.)

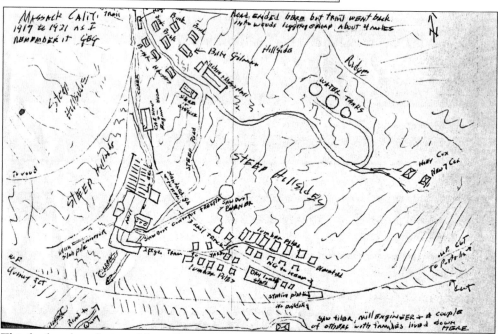

This freehand rendering of the mill town of Massack in 1917–1921 shows considerable detail and is one of the last, if not the only, record of exactly how it was laid out. Massack was located along the Western Pacific Railroad, five miles east of Quincy, and was considerably more than a logging camp—it was a town. Yet it was born, lived, and died with the demise of the sawmill.

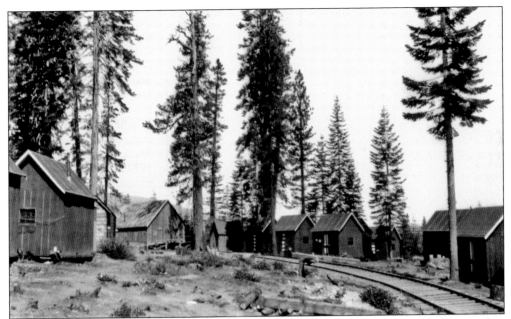

Brand new residences have just been placed at Camp No. 10 of the Clover Valley Lumber Company in August 1925. These permanent but portable "skid shacks" provided clean but basic living quarters for the loggers and, more commonly as time went on, for their families as well. Clover Valley's standard-gauge railroad is curving through the middle of the camp, extending by the cookhouse seen at left-center of the photograph. (Metcalf-Fritz Collection.)

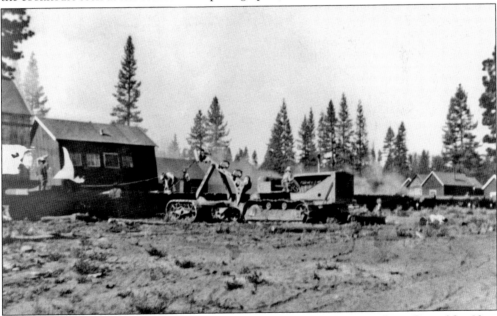

Here the Clover Valley Lumber Company is in the process of moving from Camp No. 13 to Camp No. 14 in 1938. Camp No. 13 was located in Squaw Queen Valley and was active between 1931 and 1938. By this time, families had become common in these camps. This photograph shows the little houses being cabled onto rail flat cars using Caterpillar tractors with the aid of logging arches. (Don Johns Sr. collection.)

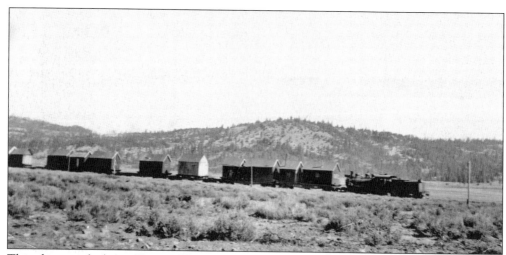

This photograph shows Clover Valley Lumber Company's cabins in transport for relocation to Camp No. 14, south of today's Antelope Lake. The Company's Engine No. 8 appears to be pushing the cars north to their new destination. Once there, the process of unloading the cabins began, and they would be skidded to their new locations, sometimes well away from the railroad. (Susan Haren collection/Don Johns Sr. collection.)

Most of these old skid shacks are long gone, but a few survive here and there. One that is in remarkably good condition is shown here at Bucks Lake, where it is used as a rental by the Bucks Lake Lodge. The old runners, or skids, still protrude below the flooring. The skids were the means by which the houses were dragged around from site to site.

Many skid shacks were disposed of to local ranching operations, which used them as line cabins, or to other private landowners who found uses for them. Others were merely left to rot in the woods. When railroad logging operations at the Old House Camp of the Feather River Lumber Company were completed about 1941, nearly all the buildings were abandoned. This site is not far from today's Lake Davis. (Plumas National Forest Collection.)

Here is another one of Clover Valley Lumber Company's surviving skid shacks, known locally as Ollie's Place. Its remote placement far from any logging camps has led to suggestions by some that it was used as a bordello. Unfortunately, vandals have all but reduced it to rubble, an all-too common occurrence throughout the county today. (Larry Williams collection.)

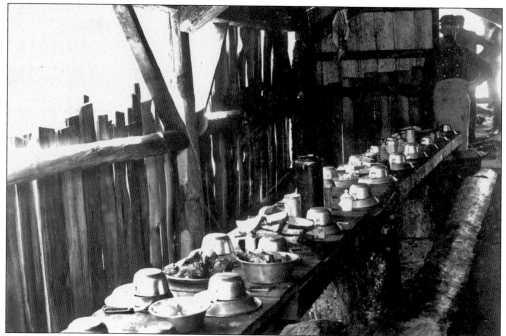

By many accounts, the most important aspect of logging camp life was the food. Woods operations could live or die based on the quality of the food provided. Many camp cooks and even some cookhouses had legendary reputations. The houses were often large, spacious buildings, but in some smaller operations, they took on a more rustic appearance.

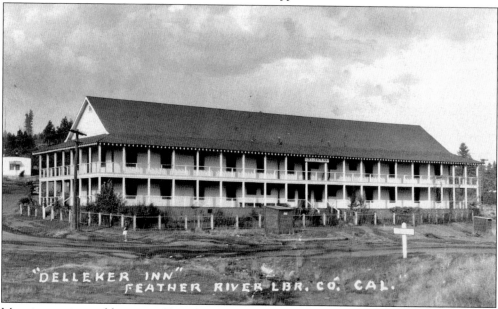

More impressive cookhouses and boarding houses were usually near sawmills. In 1923, the Feather River Lumber Company constructed what became known as the Delleker Inn. It was finished with the company's finest wood and had pool tables, a soda fountain, an ice cream parlor, a reading room, card tables, and hot showers. This view was taken in 1925. This local landmark stood along Highway 70 at Delleker for many years before being razed.

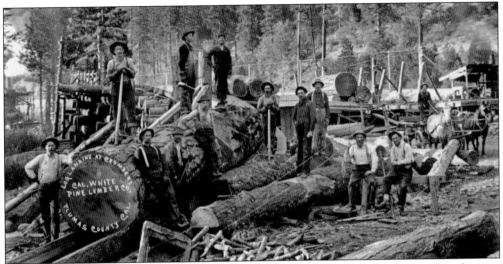

The California White Pine Lumber Company had a major landing and siding at Cromberg, as seen in this 1911 photograph. From left to right are the following: (on ground) John Edwards, George "Dutch" Marion, unidentified, Peter Ulrich, unidentified, Fred Morrison, "Big Greek," Jim Dempsey, Floyd Hill, and Walter Harvey with team and wagon; (on top of log) unidentified, Charlie Rush, and Jake Dyer. Slabs were hauled from Metcalf's mill to fire the donkey boiler. (Ruth Haddick collection.)

With the completion of the Feather River Highway in 1937, celebrations were held throughout Plumas County. Quincy hosted the majority of them. This group of local loggers spruced themselves up for a classic tug o' war contest on Main Street. From left to right are the following (first row) ? Hedrick (mascot), Frank Redkey, Red Gould, Art Turnbull, unidentified, and Marvin Hockinson; (second row) unidentified, Wardlow W. Howell, "Dago" Joe Zuconi, Don Alexander, and Milo Richards.

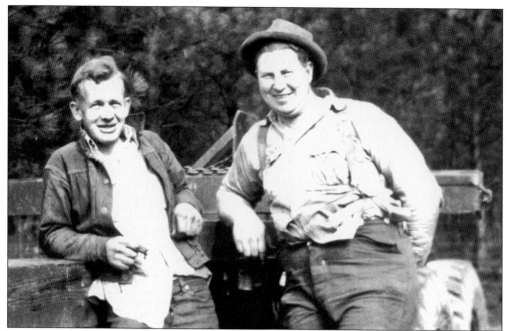

Al Olds, Rip Stead, and Bert Wilson formed Trio Logging in Taylorsville about 1942–1943. Rip died in a grader accident in 1949, and Olds left about 1952 to form his own company in Quincy. Wilson and Rip's widow, Ruth, kept the business going until about 1968. Trio Logging Company had their shop and equipment yard on the southeast corner of Main and Thompson Streets in Taylorsville. (Mary Lynn Neer collection.)

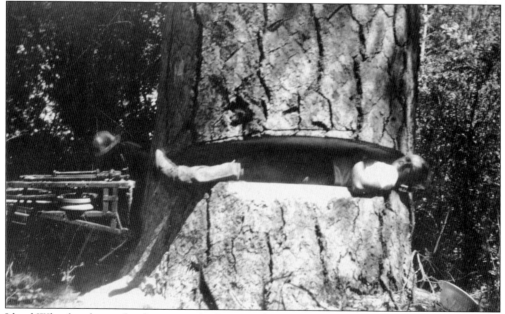

Lloyd Wheeler clowns for the camera by lying in the undercut of this huge ponderosa pine. Jack Hopkins, Wheeler's brother-in-law and later owner of Hopkins Logging Company of Greenville, lines up the back cut with their Woodsman drag saw in this 1949 photograph taken in Genesee Valley. They were cutting for the Genesee Mill at this time. (William Hopkins collection.)

As part of the logging process after the establishment of national forests, timber sale administers working for the U.S. Forest Service would monitor the progress of the timber sale, making sure there was no undue resource degradation, marking additional timber, and occasionally spot-scaling logs. In this mid-1960s shot, Forest Service employees Burl Rodgers (left) and Orville Brown pose at the end of a large sugar pine log.

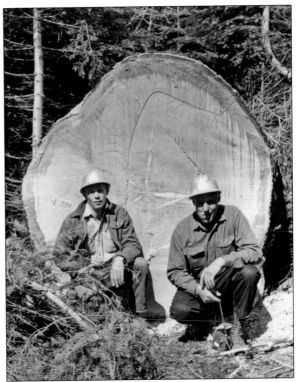

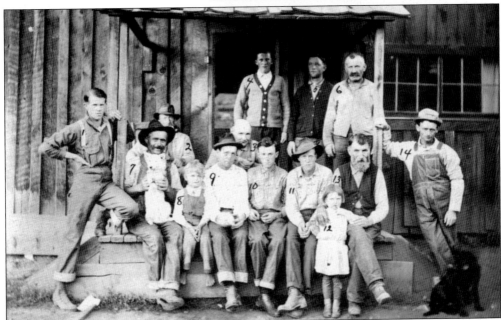

William Metcalf Jr. operated a sawmill at Spanish Ranch mainly to provide lumber products for the Quincy Mining and Water Company, one of the largest hydraulic mining operations in the county. Metcalf also provided lumber to local residents for their needs. Pictured on the boarding house porch are William Metcalf, Jr. (labeled with a number "3") and Richard Graham (labeled with number "13"). None of the rest is identified. (William Metcalf collection.)

Donald Dale Diltz and his younger brother LaVerne are shown at the corner of the Diltz family cabin at Camp No. 13 of the Clover Valley Lumber Company on August 14, 1931. Note the iron loop on the skid timber poking out from under the cabin. These were used for hooking cables or chains to when moving the cabin into place, or to load onto a flat car for transport. (Susan Haren collection.)

This cabin, car, and baby are at Camp No. 11 of the Clover Valley Lumber Company in 1927. The back of this photograph reads: "Our cabin. The tent is the one that burned so you can see why I was frightened. The baby is Billy Cass. Of course, Mrs. Cass and I each have a washing on the line." (Susan Haren collection.)

Eight

THE SAWMILLS

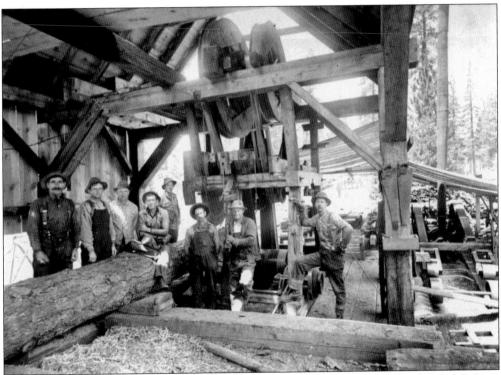

Sawmills turn the raw logs supplied by the loggers into lumber products for local and global use. Everything from structural materials such as studs, beams, and boards, to fruit and packing boxes were made in Plumas County mills. Metcalf's circular sawmill at Cromberg is shown in 1911 with the crew identified from left to right: unidentified, Ed Franklin, William Metcalf, Dan Stinchfield, Lester Haddick, unidentified, Ed Metcalf, and Jim Young. Metcalf had two other mills operating at about the same time; one at Nelson Point and the other at Spanish Ranch. Trash slabs from their operation were hauled by wagon to the California White Pine Lumber Company operations about a mile away to fire the boiler on their main donkey engine. (William Metcalf collection.)

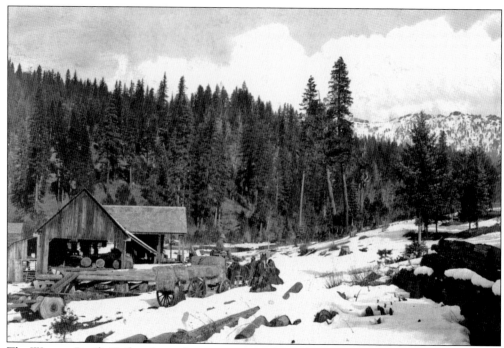

The Western Pacific Railroad was closing in on completion by 1907 when they began construction of the timber-consuming, mile-long Williams Loop. Designed to maintain the one-percent grade required by the railroad, the loop, now dirt filled, was originally built of locally sawn timbers supplied by the Gansner and Dorsch Mill, sitting along Squirrel Creek just to the east. This 1907 view of the mill shows Grizzly Ridge in the background. (Pat Jester collection.)

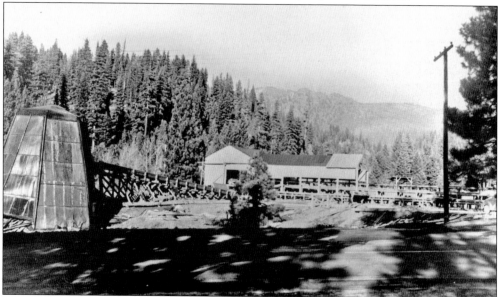

Almost 40 years after the Gansner Mill began operations, Buster Mason and Dick Hager set up their sawmill operation on the same spot. This 1946 view is generally in the same direction as the 1907 view of the Gansner and Dorsch Mill. Al Olds made the first load of his new logging company into the Mason and Hager Mill in 1952.

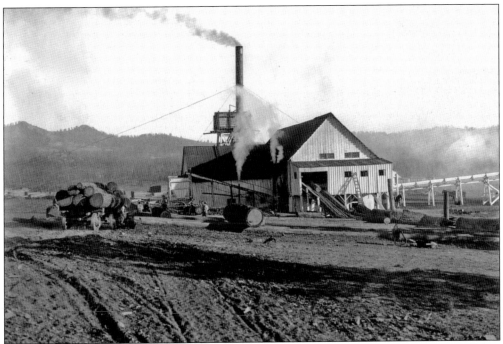

This is one of the earliest photographs of the Feather River Lumber Company Mill at Delleker, taken about 1905. Horse-drawn log wagons are being unloaded on the angled deck. Logs were then winched up the slip into the mill. Not long afterward, a large millpond was excavated. While the sawmill is long gone, a small part of the millpond is still present just north of Highway 70.

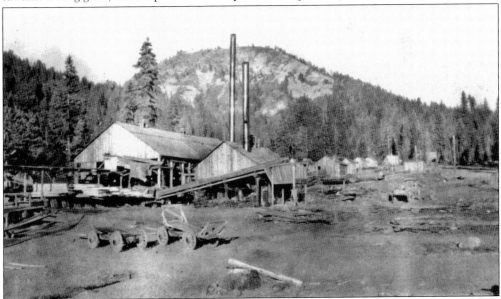

The Johnson, or Plumas Lumber Company Sawmill, and adjoining housing present a rather untidy appearance in this 1918 photograph with Jackson Peak as the backdrop. Located at the south end of the meadow that was part of the Tefft Ranch, the Johnson Mill operated for several years before the Salt Lake City–based Nibley-Stoddard Lumber Company muscled them out and set up their own operations nearby today's Mt. Tomba restaurant. (John Krepp collection.)

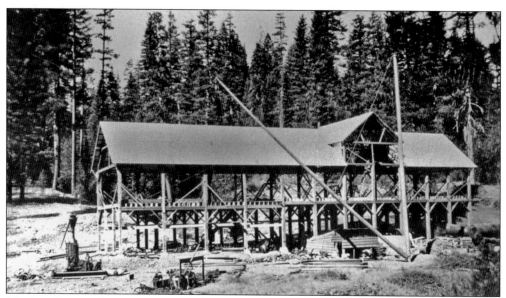

The Truckee Lumber Company of Nevada County spotted the potential in the vast stands of virgin timber located in Plumas County. By late 1915, they had acquired huge tracts of private timberland and several enormous timber sales on the Plumas National Forest. Timbers for their new Spanish Peak Lumber Company Mill, shown under construction, were supplied by Andy Robinson's sawmill at Toll Gate and the Quincy Lumber Company. (Dan Baldwin collection.)

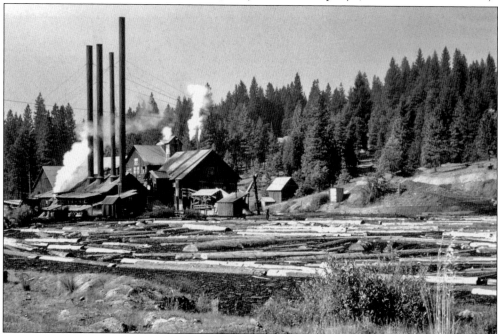

The three-story, 40-foot-by-140-foot Spanish Peak Lumber Company Mill utilized machinery from the old California White Pine Mill in Loyalton. Spanish Peak Lumber went bankrupt in 1933 and, in 1935, was purchased by the Meadow Valley Lumber Company. Over the next three decades, they enlarged the mill and made a number of improvements. In 1964, they cut their last log, an old cedar "sinker," and moved to Quincy.

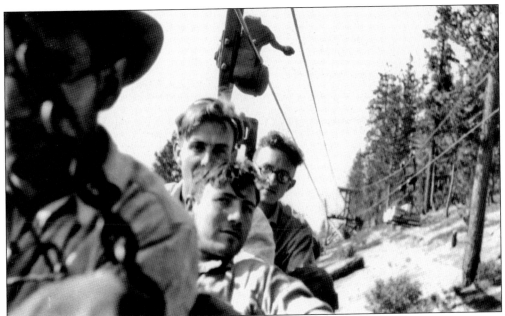

Spanish Peak Lumber Company built a five-mile aerial tramway in 1916 to ship rough lumber to their planing mill at Grey's Flat on the Western Pacific Railroad. Running in an almost-straight line north from the mill, the tramway carried 500 board feet of lumber in each packet. Members of the U.C. Forestry Camp catch a ride back to Spanish Ranch from Grey's Flat on July 12, 1926. (Metcalf-Fritz Collection.)

By 1939, the tramway was becoming a liability to the Meadow Valley Lumber Company. Determining that trucks would be more economical to haul the rough lumber to the planer, they discontinued the tramway that year. Don Johns Sr., now of Oroville, sent out the last load on the tram. Little remains of this once unique lumber transportation method, mostly in the form of rotted timbers and broken sections of cable.

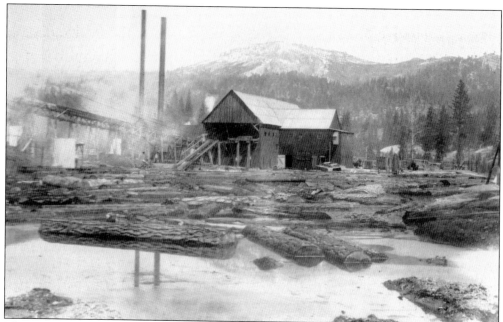

This 1920 view of California Fruit Exchange's Graeagle mill features the millpond in front, two boiler stacks for its steam-powered engines, and what appears to be the slash conveyor running off to the left. To compare this photograph to the following one, note the steep angle of the gable roof end on the main structure and the window placement on the wing at right.

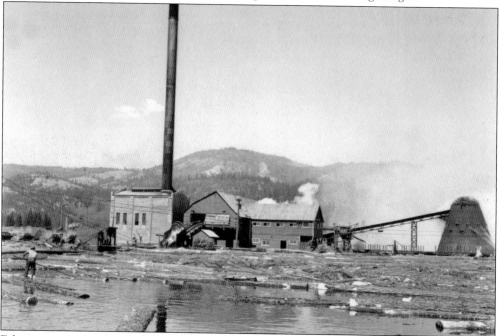

Fifteen years later, by 1935, the Graeagle mill was electric powered, with the slash burner off to the right, and the mill has apparently been rebuilt or extensively remodeled, including the addition of a dry kiln to the left of the mill. Note also the addition of a water jet sprayer for the logs going up the slip into the mill. (Plumas National Forest Collection.)

This unidentified Quincy Lumber Company pond monkey gives a demonstration of his log-rolling skills to a group of 1930s Quincy High School students safely aboard the pond raft at the company millpond. In back is the slash conveyor taking trimmings and slabs to a burn pile.

Ben Berry, a local boy, aspires to become a professional pond monkey like his companion in this 1930s view of the Quincy Lumber Company millpond in Quincy. In the background can be seen a portion of the mill and its boiler stacks for the steam-powered engines.

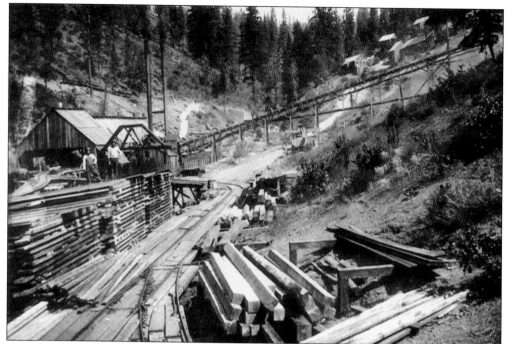

This view to the east of the Massack Timber and Lumber Company Mill shows the lumber-drying area in the foreground, toward the back at left is their Shay locomotive bringing in a load of logs to the "dry pond," and to the right on the hillside is situated the company housing for the mill's workers. The trestle in between the mill and housing may be a water line to the mill or a slash conveyor to a burn pit.

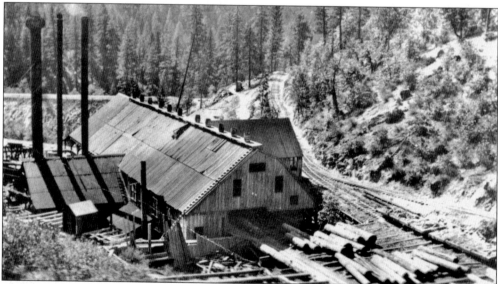

This view west of the sawmill at Massac looks toward the Western Pacific Railroad (in back) and today's Highway 70 (not seen). At right is the logging railroad that wound along the mountainside to the Taylor Creek drainage above Chandler Road. The barrels along the ridge of the roof contained water and were considered as fire protection. The mill had been reconfigured and substantially enlarged in this c. 1930 photograph.

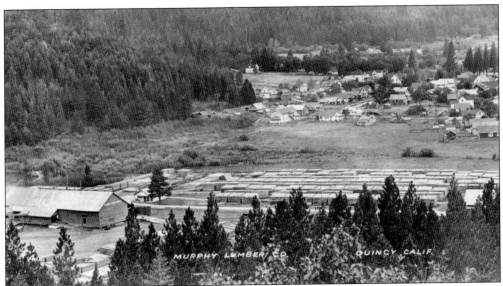

This 1920s view shows the F. S. Murphy Lumber Company works in Quincy and the stacks of drying lumber, the Quincy Railroad siding, and their office. In back are a telephone line and the Dewey Lane boardwalk from the end of Jackson Street through to the cemetery. It passed through the area that would become a millpond for the Quincy Lumber Company, which purchased the F. S. Murphy interests in 1926.

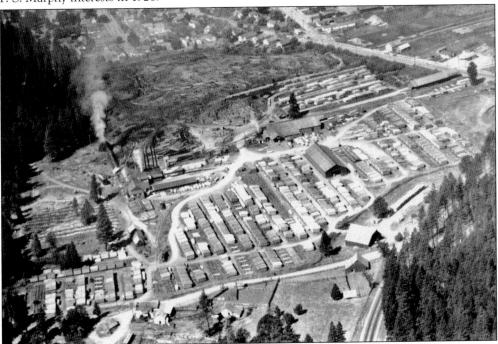

Quincy Lumber Company is seen from the air on October 1, 1949. At center are the buildings seen in the previous view of the F. S. Murphy Company. The mill with its dome-shaped burner is at left, with the millpond spread out behind it. At bottom right, an Acme Beer billboard greets travelers along the highway into Quincy. The barns nearby the billboard were once part of early day slaughterhouse operations.

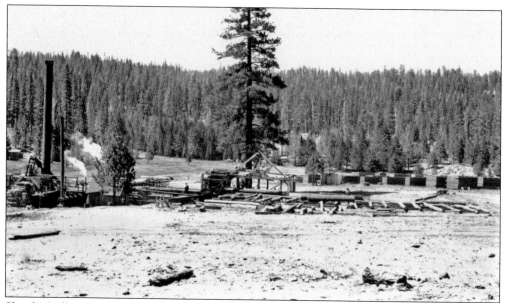

Shank's Mill is shown at Antelope Valley, now Antelope Lake, in 1935. At left is the steam-powered engine and boiler, which turned the large wooden drive wheel to the right of the shed. The mill sits in the open framework at center. At far left are several cabins for worker's housing, and in the center distance at the edge of the valley are several tents for the same purpose. (Plumas National Forest Collection.)

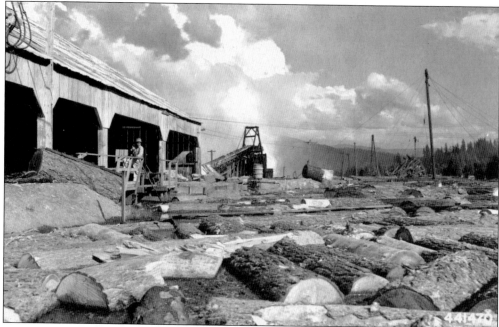

While many sawmills cut all kinds of lumber, the Cheney Stud Mill in Greenville cut only studs. Studs are structural pieces, 2-inches-by-2-inches by-92.5 inches long. This easterly look at the mill shows the pond, slash burner, and the log pile on October 12, 1945. The logs were brought from the pile to the mill with cables hooked to the spar pole seen to the right. (Plumas National Forest Collection.)

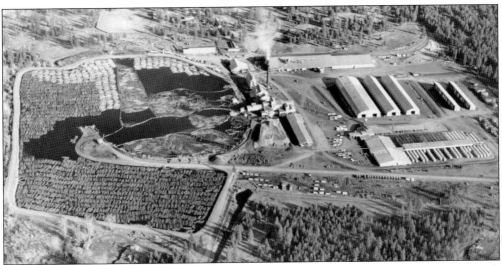

Collins Pine Company has been practicing and promoting responsible forestry on their timberlands near Chester for more than 60 years. This 1955 aerial view to the northeast shows the Collins Pine mill at center, the millpond to the left, drying sheds on the right, and the Almanor Railroad in the top right corner, as it heads toward its connection with the Western Pacific Railroad near Clear Creek.

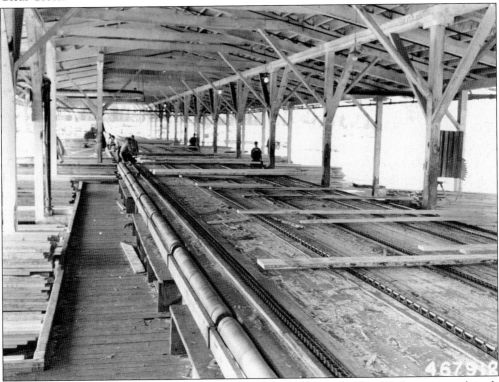

One of the most demanding jobs in sawmill work is the green chain. Here the heavy green boards are sorted by quality or "grade" and segregated before moving on to the planing mill. The sorted stacks can be seen at left. This Collins Pine green chain view, taken in 1951, shows a relatively light run of boards.

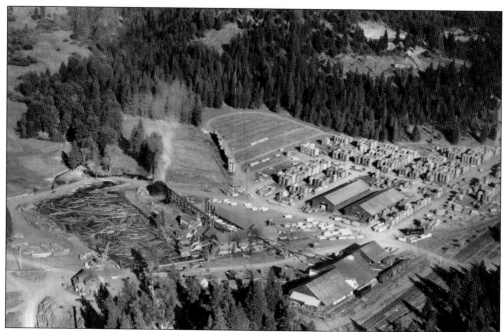

Sloat Mill, pictured looking northeast in 1950, was owned by Quincy Lumber Company. It was a large operation working on the timber from the surrounding region. About the only building left there now is the house shown in the left foreground. At top right is the water tank for the mill and its company housing, and at bottom right are the Western Pacific Railroad siding and loading sheds.

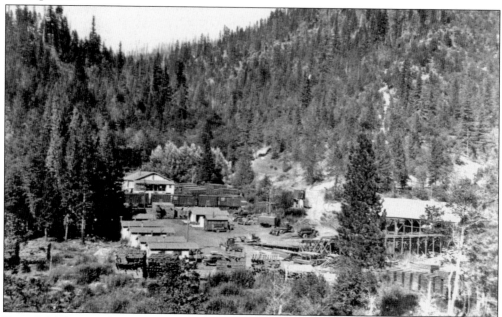

Frizzie's Mill sat at the mouth of Dixie Canyon where it meets Indian Creek about two miles north of Indian Falls. From the 1930s through the 1940s, the timber in the Round Valley Lake area to the north provided raw material for the mill. This 1934 view looks north at the mill, the company store, Indian Valley Railroad, and up Dixie Canyon.

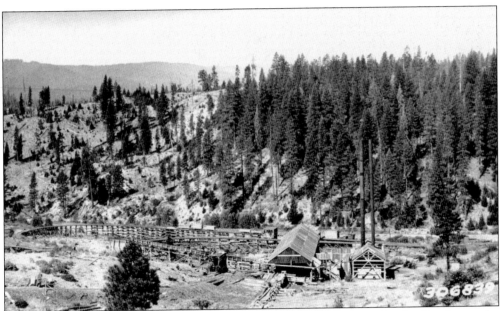

The Penman Peak Lumber Company Mill near Two Rivers shows carrier loads of lumber on the rollways and the logged-off hillsides to the west. Established about 1924, its timber came off the mountainsides behind or to the east of it, and from across the Middle Fork Feather River. The mill ran until the early 1940s, after which the machinery was sold and set up at Gray's Flat. (Plumas National Forest Collection.)

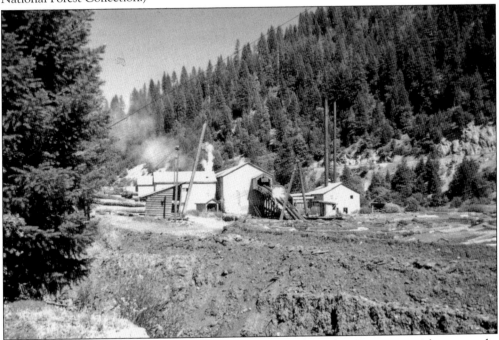

Located at Gray's Flat, once the terminus of the Spanish Peak Lumber Company aerial tramway, the Twain Lumber Company Sawmill was built by A. C. Dellinger in 1942. It was sold to High Sierra Pine Mills of Oroville in April 1951 and is shown in 1960. The mill operated until the fall of 1968. The nearby Sacramento Molding Company box factory closed in 1981. (Carol Graves collection.)

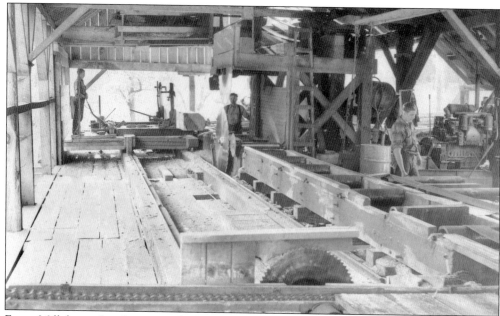

Evans Mill, located at the east end of Genesee Valley on Indian Creek, operated from the 1930s until 1962. Lafayette acquired it from Evans, and then Bill Burford and Henry Cherry purchased it. They sold to the Crawfords, and after their tragic airplane death, Erickson Brothers of Marysville purchased it. It then went to Louisiana Pacific, who later sold to Crowfoot Cedar. It partially burned in 1962 and was later razed. (Plumas National Forest Collection.)

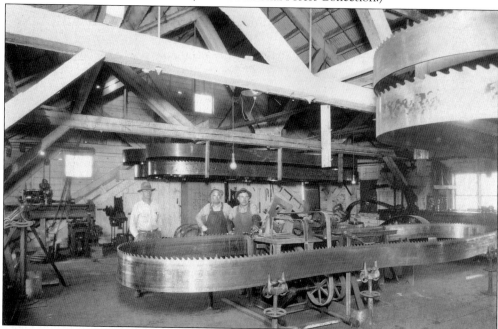

John Moore is the man in the center in this view of the inside of the filing room for the Davies Calpine Mill where they are sharpening the teeth on these long band saws. Band saws like these were a great improvement over circular saws such as the Evans operation seen above. They were faster, could cut larger logs, and could be changed out without interrupting production.

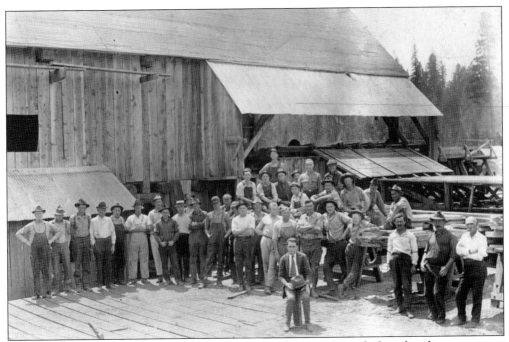

The Mutual Lumber Company had its mill on Estray Creek at the end of a railroad spur, just west of today's Greenhorn Ranch. This 1924 view shows the crew and managers assembled in front of the mill. It is probably a safe assumption that the man seated alone on a block held some kind of managerial position. (George Penman collection.)

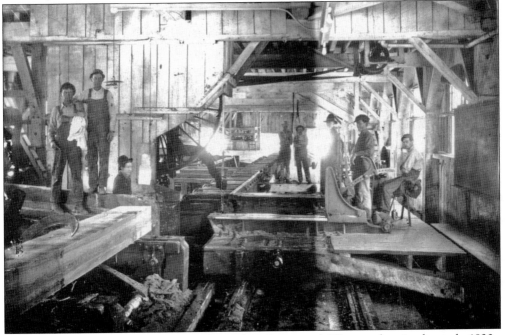

This interior view of the Spanish Peak Lumber Company Mill was taken in the early 1920s. Pictured from left to right are three unidentified men, Herbert Hard (center), unidentified, Asa McElroy, Goon Moon, and Frank Hallsted. (Bob and Barbara Moon collection.)

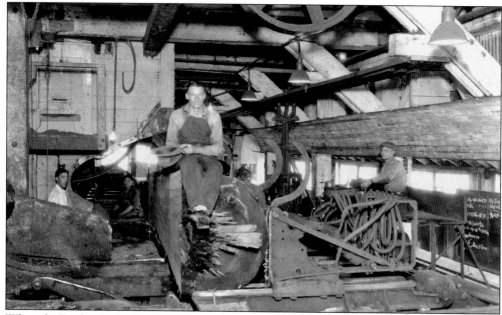

When the Feather River Lumber Company lost its mill in Delleker to fire in 1919, they constructed a new, larger band mill to replace it. A partially sawn log rests for a moment while N. F. Sitz, the sawyer at far left, and Rod Felion, the setter at right, pose for a photograph in 1929. The three men in the center, including the one sitting on the log, are not identified.

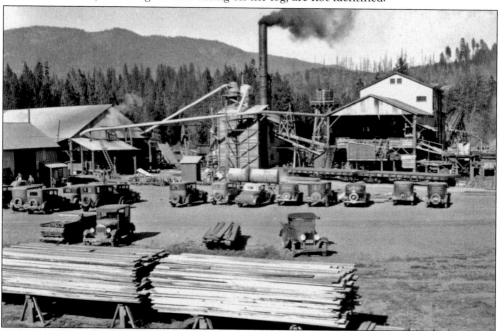

The Setzer Box Company of Greenville opened for business on September 20, 1934, with a community celebration. Cecilia Chamberlain, local bank manager, christened the new building with a bottle of California sparkling wine, then operated the levers to cut the first board from a log. Setzer operated for some 20 years or so before closing down. It is now owned by Carl Pew. (Plumas National Forest Collection.)

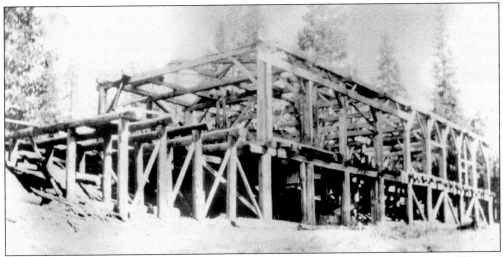

Towle Brothers built a sawmill along Slate Creek, about four miles west of Quincy, and began sawing logs in May 1914. Lumber from their mill was hauled by a combination truck and freight wagon to the railhead at Quincy, where it was shipped out on the Quincy Western Railway to connect with the Western Pacific at Quincy Junction. This view is of their mill under construction in 1913. (Violet Cole Mori collection.)

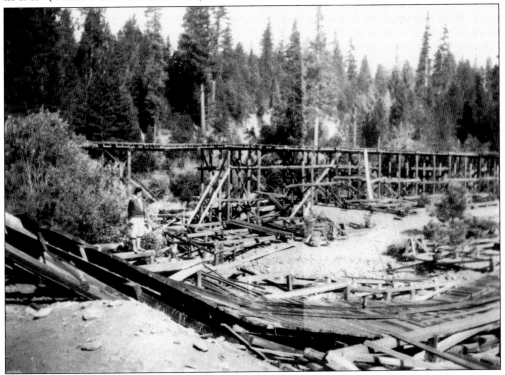

Twenty years later, in 1935, the mill was only a ruin. The available timber had been cut in the immediate area, and with competition from both Quincy Lumber Company and the Spanish Peak Lumber Company, there was simply no room for the Towle Brothers. Apparently, Spanish Peak Lumber Company absorbed what was left of the Towle Brothers operations. (Violet Cole Mori collection.)

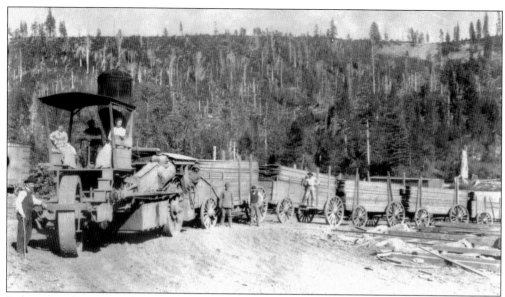

Roberts Lumber Company was one of the earliest to operate in eastern Plumas County. Based in Loyalton in Sierra County, their holdings stretched almost to Quincy. By 1910, their mill in Loyalton and much of their extensive timber tracts went to the California White Pine Lumber Company. Following bankruptcy, Roberts's holdings, much of which included residential Portola, were dispersed. This 1895 view is of their wagons and steam traction engine. (James E. Boynton collection.)

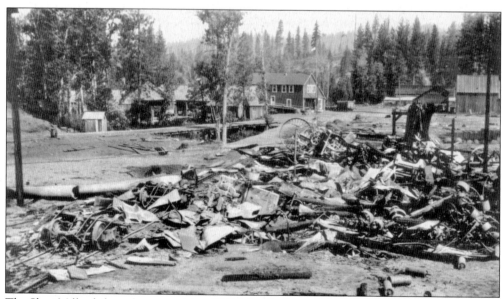

The Sloat Mill, while under ownership of F. S. Murphy, burned under suspicious circumstances in 1918. During this period of time, there were several instances of arson fires at local mills, particularly near Sloat. It was thought to be the work of subversive labor agitators or perhaps someone with a personal grudge against the company. The company store can be seen in the background.

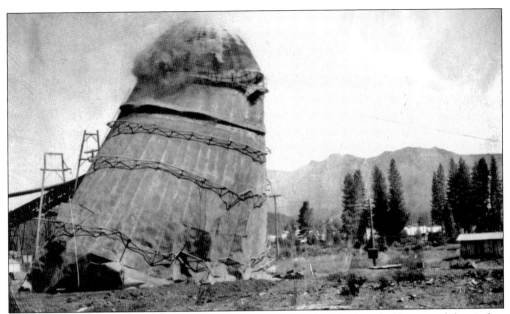

This c. 1970 photograph shows the ignominious end of one of the long-held icons of the timber industry. Teepee burners that once incinerated millions of tons of slash from sawmilling operations were banned due to air quality concerns by the late 1960s. Gone was the once familiar orange, dome-shaped glow of the screened top of the burner at night.

To this day, some aspects of the timber industry have changed little. Many logging operations now employ feller-bunchers, like Graeagle Timber Company's John Deere 753 GL, that fell, limb, and cut to length whole trees in a single operation. Even so, the industry still needs skilled loggers such as timber fallers, chokersetters, knotbumpers, and hardworking mill hands to bring the forest's raw products to the nation's and world's markets.

ACROSS AMERICA, PEOPLE ARE DISCOVERING SOMETHING WONDERFUL. THEIR HERITAGE.

Arcadia Publishing is the leading local history publisher in the United States. With more than 4,000 titles in print and hundreds of new titles released every year, Arcadia has extensive specialized experience chronicling the history of communities and celebrating America's hidden stories, bringing to life the people, places, and events from the past. To discover the history of other communities across the nation, please visit:

www.arcadiapublishing.com

Customized search tools allow you to find regional history books about the town where you grew up, the cities where your friends and family live, the town where your parents met, or even that retirement spot you've been dreaming about.